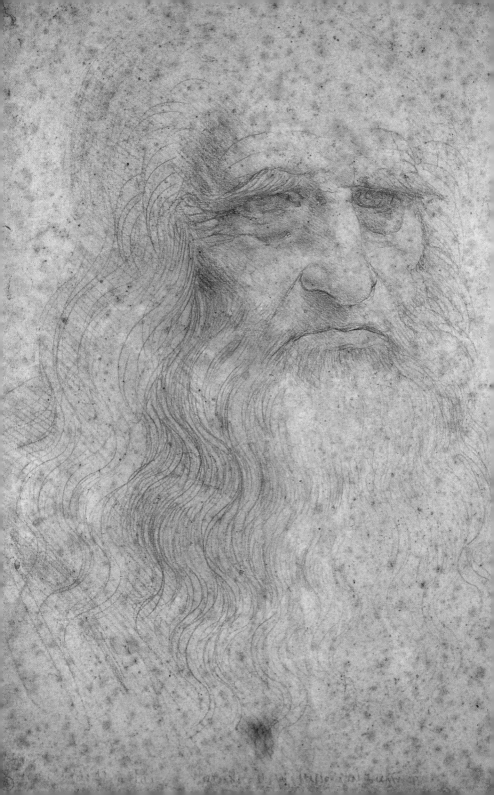

ArtBook
Leonardo

DORLING KINDERSLEY
London • New York • Sydney • Moscow
Visit us on the World Wide Web at http://www.dk.com

Contents

How to use this book

This series presents both the life and works of each artist within the cultural, social, and political context of their time. To make the books easy to consult, they are divided into three areas which are identifiable by side bands: yellow for the pages devoted to the life and works of the artist, light blue for the historical and cultural background, and pink for the analysis of major works. Each spread focuses on a specific theme, with an introductory text and several annotated illustrations. The index section is also illustrated and gives background information on key figures and the location of the artist's works.

■ Page 2. Leonardo, *Self-Portrait in Red-ochre*, Biblioteca Reale, Turin.

1452–1481

1482–1499

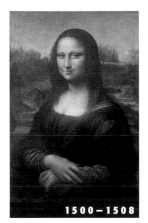

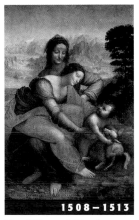

1500–1508

1508–1513

1513–1519

Index

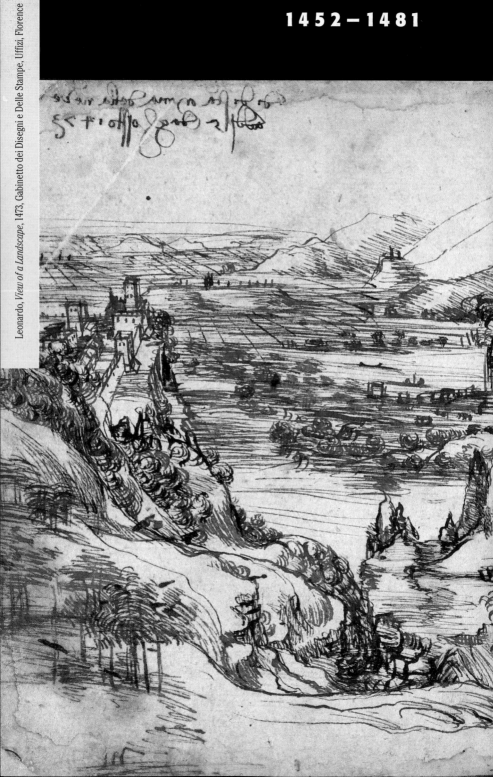

Leonardo in the Florence of the Medici

Medicean Florence: Lorenzo the Magnificent

Statesman, writer, and patron of the arts, Lorenzo de' Medici, lord of Florence (1469–92), was a key figure in 15th-century Italian political life and in humanist and Renaissance culture. When the pope cancelled the Medici bank concession in Rome, Lorenzo used public money to enlist the support of the wealthy middle classes and encouraged a radical revival of interest in philosophy, literature, and the visual arts. Crushing the conspiracy of the Pazzi family (1478), in which his brother Giuliano was murdered, Lorenzo consolidated his personal power. Aiming for a political balance between the Italian states, he ensured that the precept and example of the Florentine Renaissance spread to Rome, Venice, Milan, and Naples. The Careggi Academy, of which he was patron, and whose members included Ficino, Pico della Mirandola, and Politian, was the centre from which the concepts of Neo-Platonism were diffused throughout Europe.

■ Giovanni Delle Corniole (?), *Portrait of Lorenzo Medici*, late 14th–early 15th century, onyx cameo, Museo degli Argenti, Florence.

■ Stefano Bonsignori, *Plan of Florence*, 1483, Museo Storico Topografico Firenze Com'era, Florence. During this time the city of Florence was the most literate in Europe.

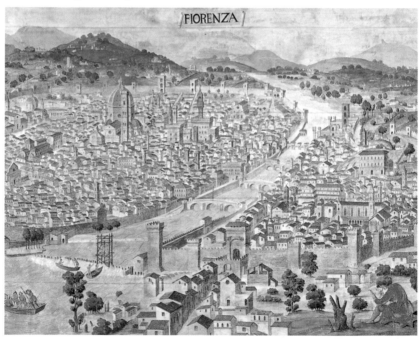

FIORENZA

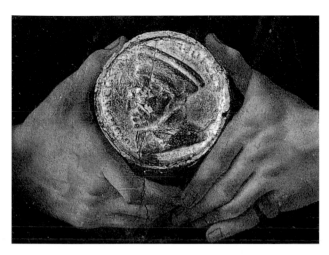

■ Sandro Botticelli, *Portrait of a Youth*, (1470–77), detail with the medal of Cosimo Medici, Galleria degli Uffizi, Florence. Cosimo (1389–1464), known as *pater patriae*, was much concerned with business affairs and owned a notable collection of antique vases, carvings, cameos, "unicorn" horns, and other priceless artefacts. Lorenzo enriched the family collection with medals, antique statues, and objects of applied art.

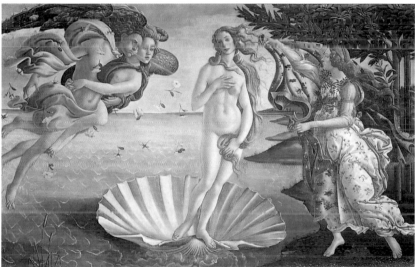

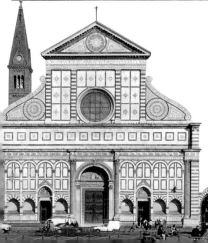

■ Leon Battista Alberti, *Façade of Santa Maria Novella*, Florence, completed in 1470. Classical architecture in Florence revived the use of inlaid marble in geometrical shapes.

■ Sandro Botticelli, *The Birth of Venus*, 1480, Galleria degli Uffizi, Florence. This painting, which derives its subject from Homeric literature, and from Ovid's *Metamorphoses* and *Fasti*, is a return to classical paganism, with allegorical overtones.

Patrons and workshops

The *Chronicles* of Benedetto Dei tell us that in about 1472 Florence boasted the presence of 40 workshops devoted to painting, 44 to goldsmithery, 50 to engraving in relief and half-relief, and more than 80 to inlaid and carved woodwork. A city bustling with commerce, Florence profited from the building fervor of Cosimo's day, and developed a culture exemplified by the products of workshops and corporations that found a market beyond the immediate region and were also exported abroad. There was a demand not only for painting and sculpture but also for goldsmiths' work, coffers, banners, stained-glass, miniatures, carvings, marquetry, wax *ex votos*, furniture, decorations for fireplaces and basins, wool and silk materials, leather and ceramics. The shops produced both objects of general everyday use and expensive specialized articles, publicly or privately commissioned: as well as the lords of the city, patrons included families known locally for their generosity, like the Tornabuoni, the Strozzi, the Sassetti, the Portinari, and the Vespucci.

■ Donatello, *The Head of Goliath*, detail of the *David*, controversially dated 1430 to 1450, Bargello, Florence, formerly in the centre of the courtyard of the Medici Palace, built by Cosimo in 1444, in the Via Larga. The sallet of the helmet is decorated with a triumphal scene, worked in onyx, showing Bacchus and Ariadne.

■ Maso di Bartolomeo, *Reliquary of the Sacro Cingolo Chapel*, 1446, Museo dell'Opera del Duomo, Prato. This object reproduces on a small scale the putti of Donatello's *Cantoria* in Florence, effectively demonstrating the successful application of Donatello's style to cabinet work and tapestry.

■ *Florentine 15th-century Cupboard*, inlaid walnut, Horne Museum, Florence. Production of cupboards in the following century moved from Florence to Liguria.

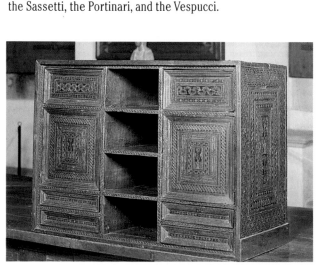

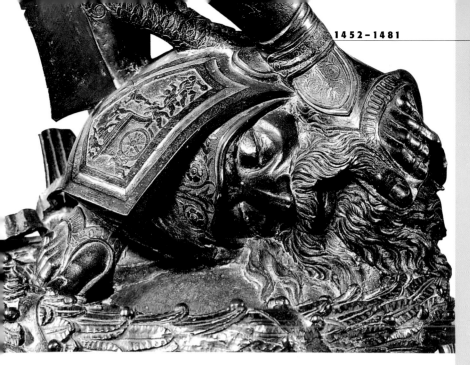

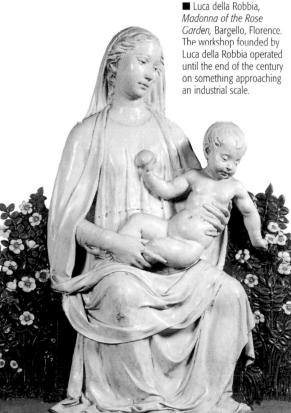

■ Luca della Robbia, *Madonna of the Rose Garden,* Bargello, Florence. The workshop founded by Luca della Robbia operated until the end of the century on something approaching an industrial scale.

■ Monte di Giovanni, *St Zenobius*, mosaic from the crypt of Santa Maria del Fiore, 1496, Museo dell'Opera del Duomo, Florence.

Apprenticeship with Verrocchio

Initially active as a goldsmith, Leonardo's master, Andrea del Verrocchio, was head of one of the most important Florentine workshops. Together with other young artists such as Botticelli, Perugino, Lorenzo di Credi, Francesco di Simone, Botticini, and Biagio d'Antonio, Leonardo, the illegitimate son of a notary from Vinci, received a comprehensive artistic education from Verrocchio. The extraordinary "polytechnical laboratory" that the young Leonardo attended from 1469 to 1476 taught not only the rudiments of painting, architecture, and sculpture, but also provided groundings in optics, botany, and music. Various early works by Leonardo, such as the famous sketch of the *Arno Landscape*, the *Adoration of the Magi*, the *St Jerome*, and a number of drawings, date from these years. He also responded to the intellectual and technical challenges of Verrocchio's dynamic style of sculpture. In the workshop Leonardo may have been involved with the plans for the Monument of Bartolomeo Colleoni, and in 1469 he may have accompanied Verrocchio to Venice, where the latter appeared as Florence's cultural ambassador.

■ Andrea Verrocchio, *Putto with Dolphin*, c.1470, Palazzo Vecchio, Florence. This naturalistic work was cast for the garden of the Villa Medici at Careggi. The symphony of movement created by the figures harmonizes perfectly with the jet of the fountain to produce a glowing visual effect.

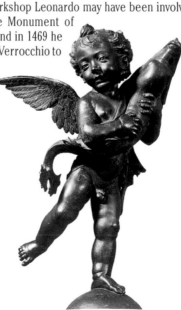

■ Andrea Verrocchio, *Head of St Jerome*, Galleria Palatina, Florence. The strongly marked plasticity of Verrocchio's paintings is reminiscent of the style of Andrea del Castagno, and he shares with Pollaiuolo a tautness and vigor of line and an acute sensitivity to the play of light. Together with Pollaiuolo, he was the key influence in the artistic activity of Florence during the second half of the 15th century. The story goes that when he saw the earliest samples of Leonardo's work, judging himself outclassed by his pupil, Verrocchio broke his brush, to devote himself henceforth only to sculpture.

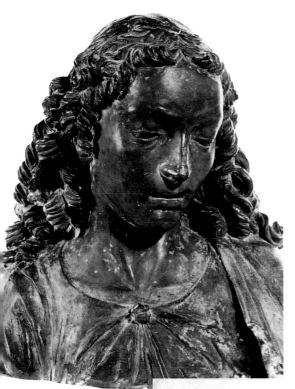

■ Leonardo, *The Young Christ*, c.1470–80, formerly Collection Gallaudt, Paris. Acknowledging a debt to Desiderio da Settignano, Verrocchio, and the Rossellino brothers, this fresh and natural terracotta is subtly dynamic in its contrasted orientation of body and head. Vasari testifies to the popularity of terracotta heads of women and putti during the period of Verrocchio; and Leonardo's entire production owes a great deal to such sculptural models, which helped him to develop his concepts of space.

■ Andrea Verrocchio, *Study of a Female Head with Elaborate Coiffure*, 1475, British Museum, London. The taste for elaborate, interlaced forms, as seen in this woman's flowing hairstyle, is very characteristic of Verrocchio's style. Leonardo, in turn, was to inherit this trait, as evident in the intertwining plants in his studies for the figure of *Leda*, and in his observations of the eddying movement of water: but whereas Verrocchio was still constrained by a more archaic and descriptive manner, dwelling graphically upon detail, Leonardo ventured further to achieve a synthesis of form.

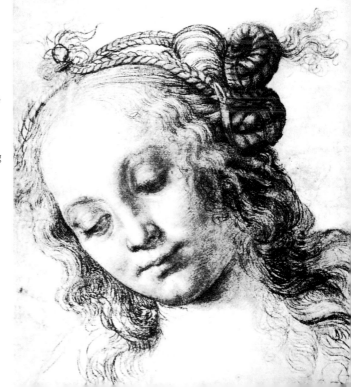

The Baptism

Commissioned by the convent of San Salvi, the painting in the Uffizi (1475–78) was a work on which Verrocchio and his pupils collaborated. In addition to that of the young Leonardo, critics have identified a contribution from Botticelli.

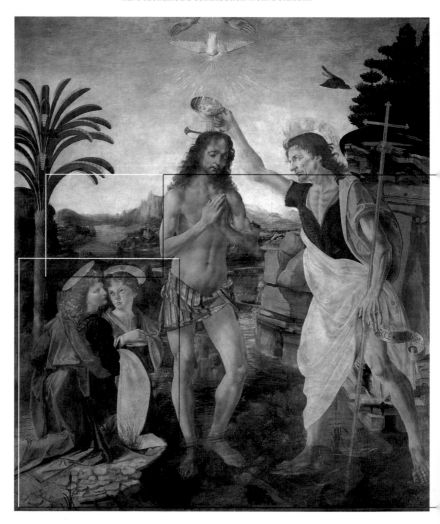

■ The naturalistic touch brought to the background suggests the involvement of Leonardo, reflecting his early interest in landscape painting. Recently concluded restoration has reinstated the very delicate transitions of tone and light in the soft, mellow expanse of water, and in the jagged mountains veiled in cloud. The principles of tonal painting are ideal for depicting the misty background as a broad river courses through the hot oriental desert wastes.

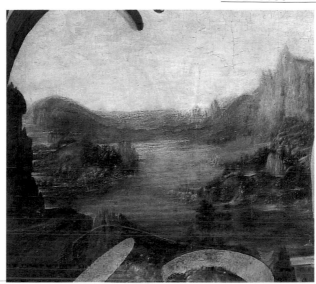

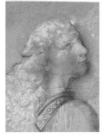

■ Leonardo, *Head of an Angel*, Biblioteca Reale, Turin. The preparatory study shows characteristics common in Leonardo's painting and drawing, notably the soft modelling and the shrewd application of chiaroscuro, elements that mark a turning point in traditional Italian and Florentine art.

■ Described poetically as a "visitor arrived from another planet", the angel on the far left, kneeling and turned sideways, may have been painted by Leonardo. The figure, with its flexibility of movement, its extraordinary softness and refinement, and its fastidious attention to physical and psychological detail, is sharply distinguished from the other characters in the scene. A fluid light penetrates the fragmented folds of the robe and the waves of the lustrous hairstyle. Leonardo also retouched the hair of the angel on the right.

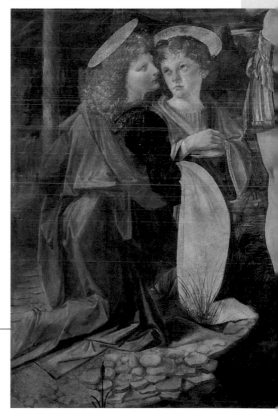

BACKGROUND

The artist and the visible world

In the wake of the revolution initiated by Giotto, artists and patrons envisaged new paths for painting, now encouraged to abandon the conventional style of religious abstraction and to reflect aspects of the real world. In the panorama of Italian and European culture, 15th-century Florence enjoyed an exceptionally privileged position: with its bold new concepts of space, its purposeful exploration of nature, and its revitalized approach to antiquity, it fulfilled all the cultural premises of the Renaissance. Brunelleschi and Alberti were credited with a discovery destined to give a new dimension to the medieval conception of space: perspective. Until then artists had tended to use foreshortening, and although objects were represented in depth, they were not mathematically related to the surrounding space. The fragile grace of Giotto was wholly superseded by Masaccio, with his massive, monumental figures. Donatello, nurtured on classical culture and motivated by an extraordinary gift for narrative, proclaimed the values of the human body and personality. The study of anatomical dissection provided artists with a new scientific instrument for understanding the workings of the human body.

■ Desiderio da Settignano, *Mary Magdalen*, polychrome wood, 1455, Santa Trinità, Florence.

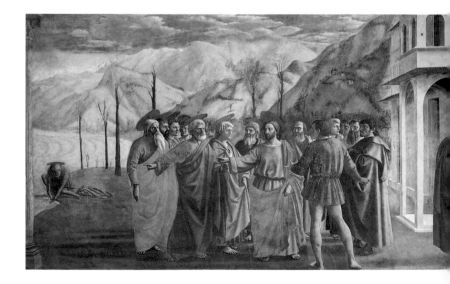

■ Donatello, *The Feast
of Herod*, 1423–25,
gilded wood, baptysmal
font of the Baptistery,
Siena. A master of
perspective and
moulding techniques,
the sculptor achieves
a powerful contrast
between the foreground
figures and the receding
background levels.

■ Lorenzo Ghiberti,
Stories of Joseph, after
1439, Porta del Paradiso,
Baptistery, Florence. By
now emancipated from
medievalism, Ghiberti
espoused the

perspective principles
developed by Brunelleschi
and Donatello, affirming,
both as a theorist and an
artist, the intellectual
quality of art.

■ Antonio del
Pollaiuolo, *Hercules and
Antaeus*, c.1475, Galleria
degli Uffizi, Florence.
Working in Florence at
a time when the practice
of dissection and
the study of human
anatomy were on
the increase, Antonio
used his sculptural
and pictorial talents
to concentrate on the
theme of the nude
figure in action
at moments of
maximum emotional
and dynamic tension.

■ Masaccio, *The Tribute
Money*, detail of the
Stories of St Peter,
1424–27, Brancacci
Chapel, Santa Maria
del Carmine, Florence.
This is the fundamental
scene of the whole
cycle, commissioned
to Masolino and
Masaccio, and sub-
sequently completed
by Filippino Lippi.

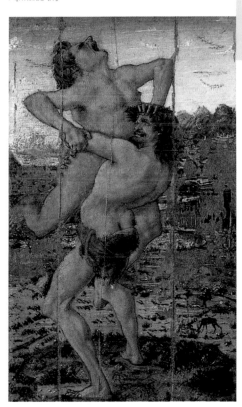

The Annunciation

Intended for the convent of Monte Oliveto, the picture in the Uffizi (1470–75) shows a weakness in its fusion of parts, even though Leonardo's very personal touch is to be seen in the elements of perspective, the botanical details, and the harbour scene in the background.

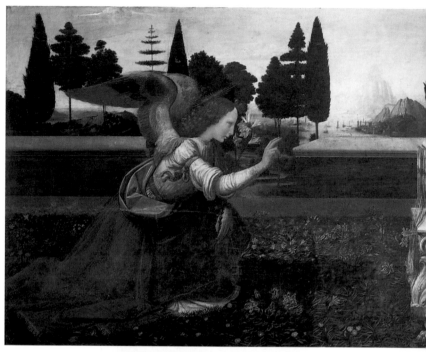

■ Andrea Verrocchio, *Tomb of Cosimo Medici*, 1470–72, Sacrestia Vecchia, San Lorenzo, Florence. Leonardo's point of departure for the invention of Mary's lectern, a kind of ancient altar, was probably the bronze sarcophagus of his master, made with a taste for decorative detail characteristic of a goldsmith.

■ Leonardo, *Study for the Madonna of the Annunciation*, Gabinetto Nationale dei Disegni e delle Stampe, Rome. This study for the cloak of a kneeling Madonna displays extraordinary accuracy in the detail of the layered drapery, illuminated by lighting that is reminiscent of Flemish experiments.

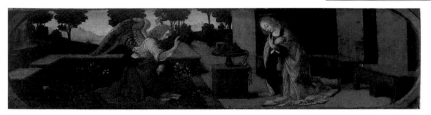

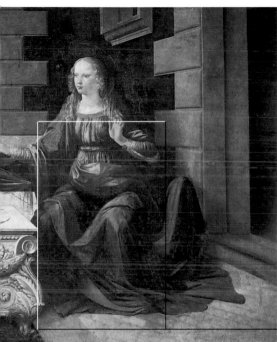

■ Leonardo, *Annunciation*, 1478–80, Musée du Louvre, Paris. Part of the predella of the *Madonna di Piazza* of Pistoia Cathedral, commissioned to the Verrocchio workshop (1478–85), attributed to Leonardo and Lorenzo di Credi, and typical of the former in its fusion of figures and surroundings. The figure of Mary is comparable to a drawing in the Uffizi.

■ Leonardo states in the *Treatise on Painting*: "One ought not to let the contour of the figure be broken by too many lines or interrupted folds of drapery…the cloth must not appear unoccupied…its effect is to clothe and gracefully surround the limbs."

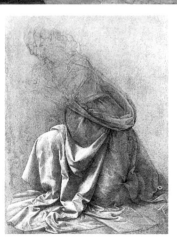

Painters from outside Florence

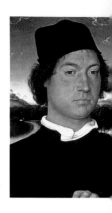

The supreme innovators of 15th-century painting hailed from Tuscany and Flanders. With the decline of the unitarian concept of International Gothic, but prior to the establishment of Italian Renaissance models, the influence of Flemish painting spread rapidly through Europe. Its focal points were not confined to Flanders itself and to the adjacent German lands but extended to France, Spain, and Switzerland. The northern painters introduced a new manner of evoking reality, of

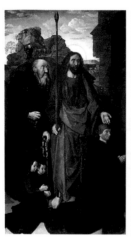
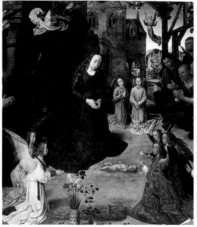
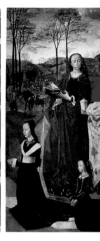

rendering the reflections of light, of portraying the skin and material essence. The Flemish artists were not intellectuals, but were sharp observers of natural detail, and displayed an extraordinary descriptive capacity in their representation of open landscape. The potential scope afforded by their use of oils enabled them to create masterpieces of painterly technique. Some of the Flemish artists moved to Italy, others accepted work on commission; examples of both were on show in Florence, a city that was an early follower of the new style. Among the many foreign artists represented were the Frenchmen Jean Fouquet and Nicolas Froment, and the Flemish-born Jan van Eyck, Petrus Christus, Hugo van der Goes, and Hans Memling, the last already known to Sandro Botticelli and whose branches of delicate foliage were reworked by Raphael.

■ Hugo van der Goes, *Portinari Triptych*, 1476–78, Galleria degli Uffizi, Florence. This triptych, placed in Sant'Egidio in 1483, was commissioned by Tommaso Portinari, the Medici banker in Bruges. Ghirlandaio derived a detail of the central panel of his *Adoration of the Shepherds* at Santa Trinità from this work.

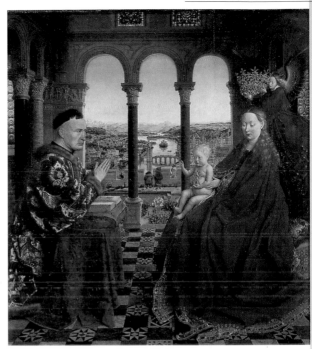

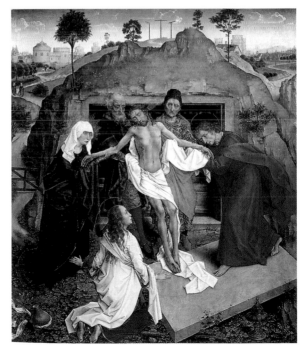

■ Hans Memling,
*Portrait of Benedetto
Portinari*, 1487, Galleria
degli Uffizi, Florence.
Memling designed this
portrait with a rural
background. This was
to have vast repercussions
in early 16th-century
Italian painting.

■ Jan van Eyck, *The
Madonna of Chancellor
Rolin*, c.1432, Musée
du Louvre, Paris. At
one time van Eyck
was reputed to have
invented oil painting,
although it had already
been known in the
classical world. This
technique permitted the
artist to achieve greater
nuances of tone, to
enlarge the color range,
and to obtain darker
effects in the modelling.

■ Rogier van
der Weyden. *The
Entombment* , c.1450,
Galleria degli Uffizi,
Florence. The master
of Hans Memling, Rogier,
who was in Rome for the
Jubilee Year celebrations
of 1450, also made
journeys to Ferrara,
Florence, and Milan.
Rogier was official
painter to the town of
Brussels and a pupil
of Robert Campin; his
works, full of allusions
to Jan van Eyck and
sensitive to the Italianate
use of space, were in
demand throughout
Europe. In the second
half of the century links
between the two schools
grew closer: the Italian,
synthetic and
monumental, and
the Flemish, analytical
and true to life.

The theme of the Madonna and Child

Leonardo turned industriously to the subject of the Madonna and Child during the early years of his output. He showed considerable originality in his approach to the themes of Christian iconography that gave him the opportunity to introduce new developments in form and content. In this context he produced a number of paintings and a large quantity of drawings and sketches. Here he exercised his talent for composing groups and for mingling symbolic elements within a scene conditioned by the movements, gestures, and expressions of the constituent characters. The theme of the mother and son portrayed in an intimate moment enabled Leonardo to focus upon the emotional dimension in which he excelled, and was also based on the example of the Florentine painting of Filippo Lippi. Among these symbolic components were flowers and animals – the carnation, the thistle (as in the *Madonna Litta*), the cat, and the lamb – all rendered with the deepest empathy and naturalistic concern. The complexity and subtlety of detail in Leonardo's sacred paintings set new standards.

■ Leonardo, *Sketch for the Madonna with the Cat*, recto, 1480–81, British Museum, London. This subject derives from the legend of a cat which gave birth at the moment of the Nativity.

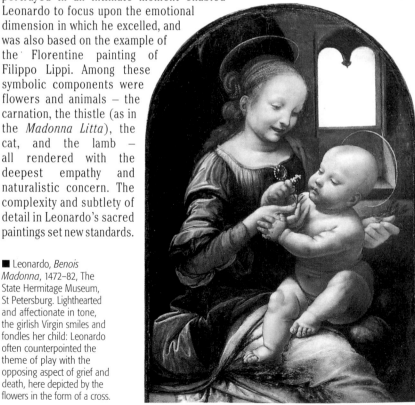

■ Leonardo, *Benois Madonna*, 1472–82, The State Hermitage Museum, St Petersburg. Lighthearted and affectionate in tone, the girlish Virgin smiles and fondles her child: Leonardo often counterpointed the theme of play with the opposing aspect of grief and death, here depicted by the flowers in the form of a cross.

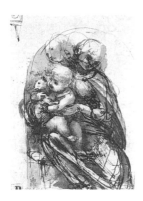

■ Leonardo, *Sketch for the Madonna with the Cat*, verso, 1480–81, British Museum, London. The formal experimentation continues on the other side of the page.

■ Leonardo, *Dreyfus Madonna*, or *Madonna with the Pomegranate*, c.1470, National Gallery of Art, Washington. Opinion among critics is divided between Leonardo, Verrocchio, and Lorenzo di Credi as to who is responsible for this small panel, which shows strong similarities to the *Madonna with the Carnation*. The Venetian flavor of the painting, constructed on an almost Bellini-like chromatic scale, suggests a date of about 1469, the year in which Verrocchio made his trip to Venice, possibly followed by Leonardo. Yet the picture, overall, shows a lack of harmony, the two figures hardly relating either to the architecture or the background, testifying to the still experimental character of the work.

■ Milanese pupil of Leonardo, *Madonna Litta*, c.1490, The State Hermitage Museum, St Petersburg. Conceived in Leonardo's workshop, this painting was brought to completion by a pupil. Contrary to the example of the *Benois Madonna*, the painter sought to convey an idealized image in the regularity of the Virgin's face and the overall harmony of separate elements.

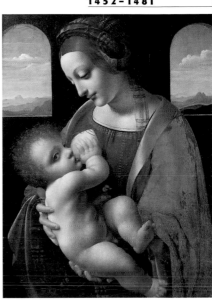

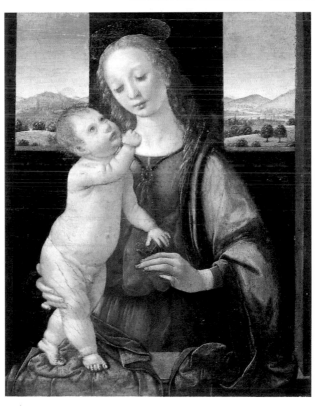

1452–1481

Madonna with the Carnation

Leonardo's first autonomous work, this painting, also known as the *Madonna with a Vase of Flowers* (1478–80, Alte Pinakothek, Munich) marks a liberation from the graphic style of Verrocchio and a new awareness of three-dimensional values and of light. The background is reminiscent of Jan van Eyck.

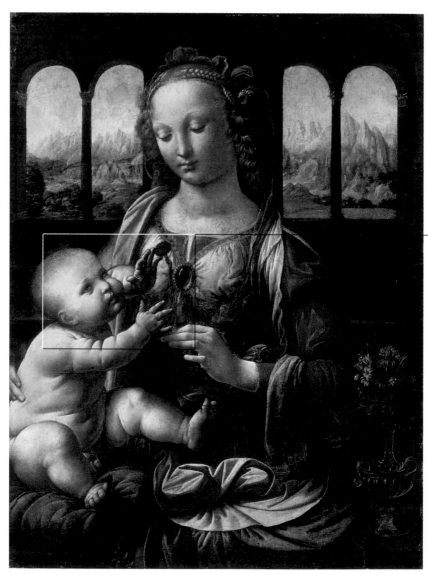

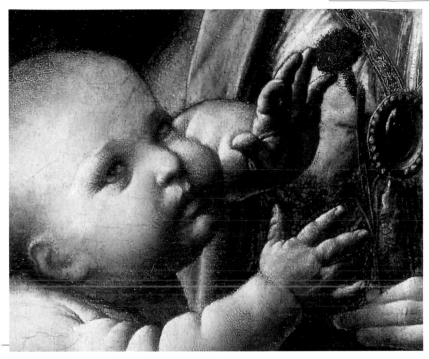

■ The symbolic element that links the two figures is the carnation with its cruciform petals, which Mary holds delicately between her fingers and which Jesus, with grave features, stretches out to grasp. Both the gaze and the arms of the Child are directed towards the flower, a symbol of the Passion, as if He is aware of the drama of his destiny. Leonardo often counterpoises reality and symbol by balancing opposing extremes. Here again he successfully re-interprets traditional iconography in an intimate marriage of the natural and the symbolic. Leonardo's late paintings of the Madonna and Child, with or without additional figures, achieve an even greater sense of harmonious inter-relationship and fluid movement

■ Raphael, *Madonna with the Carnation*, 1509–12, National Gallery, London. Indebted to Leonardo for the invention and positioning of the group, Raphael softens the symbolic, dramatic tones of the Leonardo version. He emphasizes the dynamic conjunction of the two figures within a looser, more fluid compositional scheme, akin to the *Benois Madonna* prototype. Raphael's characters reflect little of the psychological density of Leonardo's: there is an eloquent simplicity in the interplay of the hands of Mary and the Child, which no longer mirror the inner tension of the symbolic event. The instinct for decoration has here superseded the sense of drama.

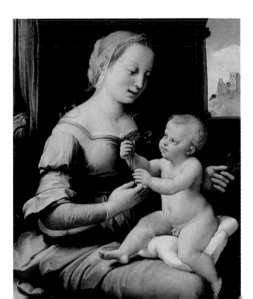

BACKGROUND

Flemish echoes in Florentine painting

T he cultural exchanges between Flanders and Italy in the 1470s set in motion a transformation in European painting lasting approximately the next 40 years. This change was accelerated by the diffusion of northern models which signalled the final decline of the Gothic Style. In Florence, Fra Angelico derived his lighting and compositional elements from Rogier van der Weyden; and Domenico Veneziano – like Bellini and Antonello in Venice – similarly acknowledged a debt to the Northern painting already familiar in his native city. Flemish artists received a warm welcome in Florence, which also had strong commercial links with Flanders. Local painters assimilated the ideas and rules of Northern schools, without abandoning the intellectual, rationalistic approaches consistent with their upbringing. Among those of Leonardo's generation who were attracted by the new possibilities offered by landscape, the close observation of nature, and the rich nuances of color, were Lorenzo di Credi, Antonio and Pietro del Pollaiuolo, Ghirlandaio, Giovanni di Gherardo del Fora, Biagio d'Antonio, Piero di Cosimo, Filippino Lippi, and the Master of the Kress Landscapes.

■ Fra Angelico, *The Entombment*, from the predella of the St Mark's Altarpiece, 1438–40, Alte Pinakothek, Munich.

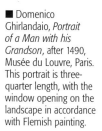

■ Domenico Ghirlandaio, *Portrait of a Man with his Grandson*, after 1490, Musée du Louvre, Paris. This portrait is three-quarter length, with the window opening on the landscape in accordance with Flemish painting.

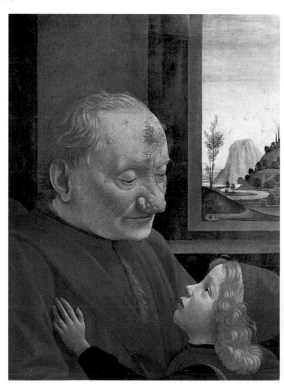

■ Piero di Cosimo, *Portrait of Francesco Giamberti*, after 1482, Rijksmuseum, Amsterdam. Pendant to the *Portrait of Giuliano da Sangallo*, this portrait does not idealize the model, as is evident in the details of the bent ear and the thick vein on the temple.

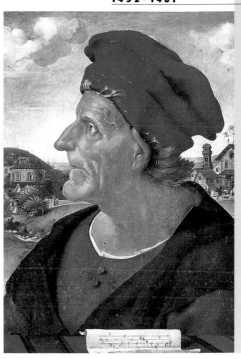

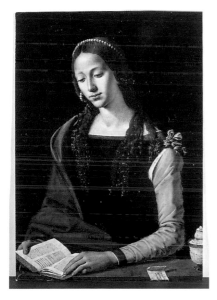

■ Piero di Cosimo, *Portrait of a Lady Dressed as the Magdalen*, early 16th century, Galleria Nazionale di Palazzo Barberini, Rome. This picture is notable for its transparent luminosity, and is also reminiscent of Filippino's work.

■ Antonio del Pollaiuolo, *St Michael and the Dragon*, c.1460–70, Museo Bardini, Florence. The fashion for representing a landscape bisected by a river and dotted with trees is shared with Alessio Baldovinetti.

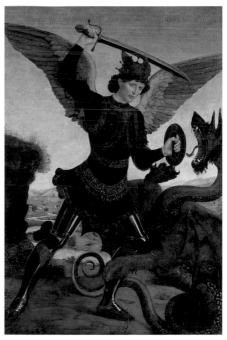

1452–1481

Ginevra de' Benci

Painted in about 1475, the year of the subject's marriage, the Washington portrait, part of which, including the hands, was cut at the bottom, shows the subject against an aqueous landscape. The presence of the juniper (*ginepro* in Italian) is an allusion to the woman's name, Ginevra.

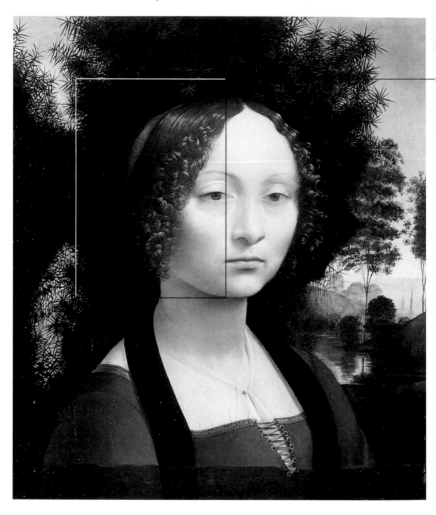

■ The reverse of the painting shows more allegorical features: on a porphyry ground, set between the leaves of symbolic branches of palm, laurel, and juniper, is a scroll with an emblem, "Virtutem forma decorat", alluding to the name and virtues of the subject.

■ Leonardo, *Study of Hands*, c.1485, Royal Library, Windsor. This portrait, subsequently cut short by about a third – which can be seen from the cut on the retro – originally included the subject's hands, as depicted in the drawing.

■ The care lavished on the glowing light that falls on the ringlets harks back to the work of Memling, van Eyck, and Petrus Christus. Color is here used analytically to combine with a new atmospheric vision of space.

■ Andrea Verrocchio, *Lady with a Nosegay*, c.1475–80, Bargello, Florence. Posed in keeping with Verrocchio's sculptural principles, the bust of Ginevra de' Benci is a typical Florentine model enlivened by Flemish example.

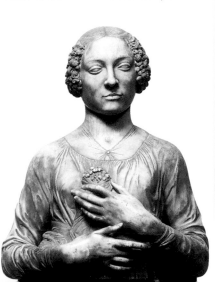

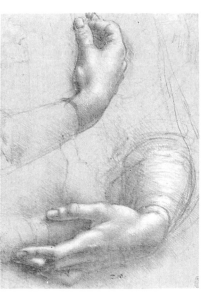

Light and shadow

■ *Crown of Pyramids around a Sphere*, design from the Ashburnham Codex II. The infinite shadows produced by an illuminated body take the form of a pyramid. For Leonardo shadows are more powerful than light, because they can never entirely be eliminated.

Among the studies conducted by Leonardo into the phenomena of the natural world, those relating to light and shadow were of primary importance: touching upon a fundamental element of the painter's art, they were essentially scientific in character, and they commanded enormous interest within artistic circles. Stimulated as well by the refined optical effects of Flemish painting, Leonardo's work marked a decisive turning-point in Florentine and Italian tradition. The so-called "Leonardesque *sfumato*" stemmed from natural variations in the interplay of light and shade on objects, which determines the artistic conceptions of volume, depth, breadth, and color, subject to infinite variations of tone and changing according to the nature of the surface. Leonardo's theories assigned a greater importance to shadows than to light. In his *Treatise on Shadow and Light*, Leonardo conducts a complex survey of shadows, classified on the basis of quality, quantity, kind, and form, and defined as "primitive", "derived", and "repercussed". Similarly, light is differentiated on the basis of the surface on which it falls, and is described either as "light" or "lustre".

■ Detail of the background landscape of the *Annunciation*. The atmosphere, which to the observer functions as a kind of lens, imposes its own perceptive values, and removes individual color from the objects.

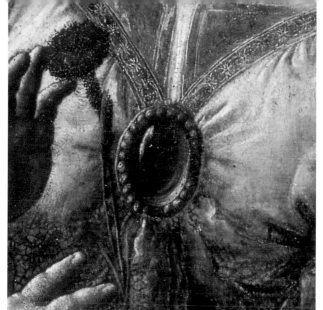

■ Detail of the *Virgin with the Carnation*. Leonardo reveals a keen understanding of the quality of materials, studied here in conjunction with the colored surfaces. The painter is well aware that the reflection of light varies according to whether the surfaces are transparent or opaque, concave or convex. Analysis of the "lustre", or light reflected from a bright surface, is a subject treated in the *Treatise on Painting*.

■ *The Apostle Philip*, detail of the *Last Supper*. Modern restoration has reinstated the reflected glow at the juncture of the Apostle's chin and neck. Leonardo's use of chiaroscuro achieves effects very different from those attained by Michelangelo, who bathes the bodies in a clear, limpid light, heightening the luminous quality in order to throw the outlines into relief.

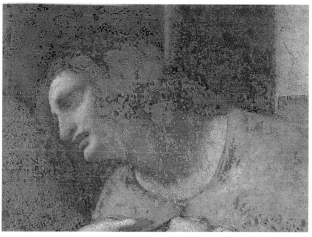

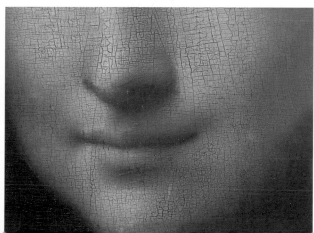

■ The *Mona Lisa*, detail. The construction and modelling of the face illustrate the changing effects of light and shade. The area of shadow on either side of the mouth suggests the inner nature of the sitter and forms the visual substance that unifies figure and landscape.

1452–1481

St Jerome Penitent

Probably painted between 1480 and 1482, the incomplete *St Jerome* of the Vatican Library marks a progression towards an increasingly complex relationship between the figure and the elements of the surrounding space.

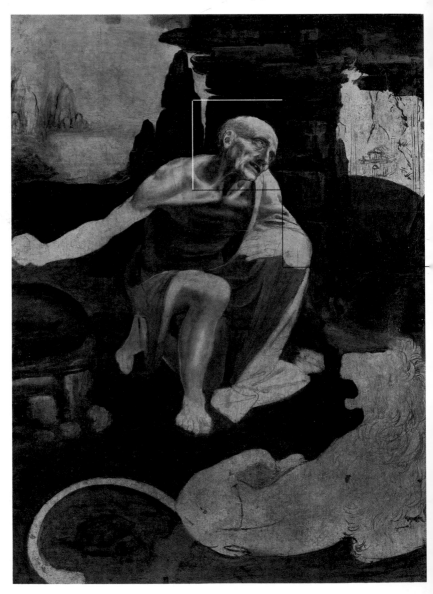

■ Leonardo, *The Hanged Body of Bernardo Baroncelli,* 1478, Musée Bonnat, Bayonne. The focus on anatomical detail in the saint's face and neck stems in part from the studies Leonardo made of corpses. In Florence he drew from life the dead body of the killer of Giuliano Medici, hanged publicly in front of the Palazzo Vecchio.

■ *Personification of Geometry,* 1489–1500, frontispiece to the *Antiquariae Prospecticae Romanae.* The pose of *St Jerome* is repeated on the frontispiece of the short poem dedicated to Leonardo and attributed by some to Bramante.

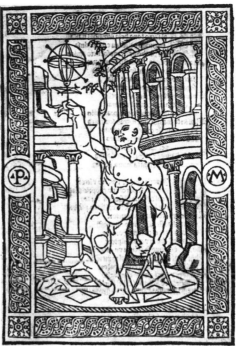

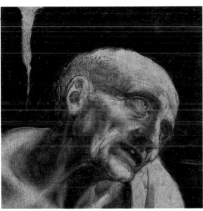

■ At some stage the uncompleted panel was cut into two pieces. The upper part, evidently corresponding to the saint's face, and presumably more marketable, is said to have been found by Napoleon's uncle, Cardinal Fesch, in a Roman junk shop, offered as a table top. Years later he discovered the lower fragment being used as a wedge for the bench of a shoemaker. Typically, Jerome's face appears at a three-quarter angle; emaciated and imploring; it testifies to Leonardo's flair for facial mimicry, all the more dramatic for its setting against the dark background of the cave and the rocky landscape veiled in mist.

■ Leonardo, *Drawing of a Church,* 1495–97, Gallerie dell'Accademia, Venice. Executed ten years after *St Jerome,* the drawing shows a building in the style of Alberti, and is similar to that in the background of the painting, where it provides a perspective orientation to the scene. It is also the point on which the saint can fix his gaze.

The speaking gesture

Leonardo, who derived his interest in moving figures from the tradition of the Florentine workshops, had an unprecedented understanding of body language. He brought a sense of palpable life to the human figure ("movement and breath" in the words of the art historian Vasari), seeing it as the vehicle of action, thought, and emotion. It is enough to think of either the *Adoration* or the *Last Supper*, both compositions based on a subtle range of emotional effects that animate the figures according to age, character, intention, and feeling. Although contemporary artists were also concerned with the theme of movement, their works exhibit no comparable skill in conveying a sense of inner meaning, whereas Leonardo was convinced that actions and gestures revealed a person's mental and emotional content. This very modern attitude was to be re-emphasized by the French philosopher Diderot in the age of Enlightenment.

■ Leonardo, *Study for the Madonna with the Cat*, 1478–80, British Museum, London. Fascinated by the natural world, the ebb and flow of the life-force, Leonardo frequently chose subjects encountered at first hand in the course of everyday affairs.

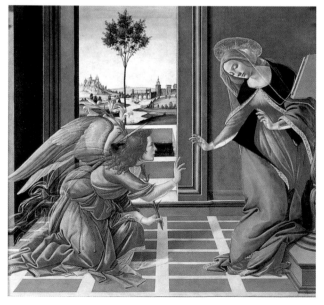

■ Sandro Botticelli, *The Cestello Annunciation*, 1489–90, Galleria degli Uffizi, Florence. Leonardo recommended his painters to maintain a measured emphasis in the gestures of the figures they represented, appropriate to the nature of the scene in which they appeared. It was this maxim that originated his objection to the agitated, frenetic figures of Botticelli ("The angel should not chase Our Lady from her chamber.")

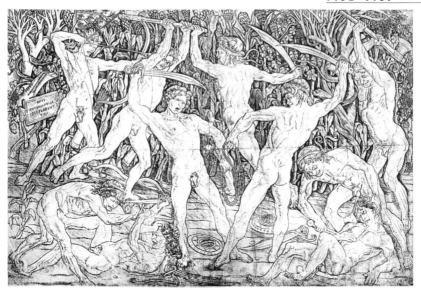

■ Antonio del Pollaiuolo, engraving of the *Battle of the Nudes*, 1471–72, British Museum, London. Leonardo's argument also extended to those human figures whose muscles were too blatantly defined, and whose movements appeared wooden and lacking energy. In his quest for the golden mean, Leonardo avoided any form of excess.

■ Pietro Perugino, *Pietà*, 1494–95, Galleria degli Uffizi, Florence. Even Perugino, who according to Leonardo presented his figures without an adequate variation of muscular detail, was not exempt from criticism. Leonardo avoided such uniformity by studying practical anatomy.

■ Domenico Ghirlandaio, *Confirmation of the Franciscan Order*, 1482–86, Santa Trinità, Florence. A slow, precise, descriptive narrator, Ghirlandaio did not appeal to Leonardo because of his regularity of style and the apparent lack of feeling of his figures.

1452–1481

Adoration of the Magi

Commissioned in 1481 by the monks of San Doneto at Scopeto, the painting in the Uffizi is incomplete; even so, enough of it exists to recognize the revolutionary elements of its iconography, style, and symbolism.

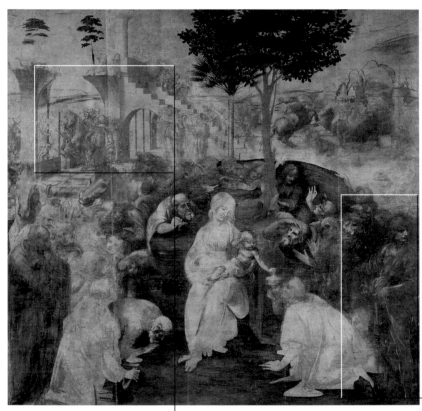

■ Echoes of Leonardo's masterpiece would later be seen in Raphael's studies for the cartoons of the *Disputa* and *The School of Athens,* in which the figures demonstrate the same degree of narrative force.

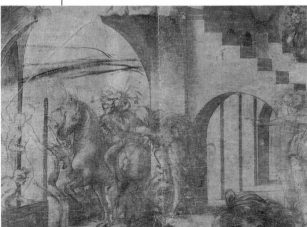

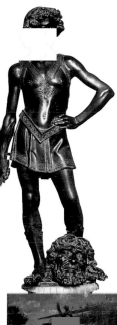

■ Andrea Verrocchio, *David*, c.1475, Bargello, Florence. This elegant bronze sculpture symbolizes the humanist culture embodied in the Medici's Laurentian Library. In 1476, it was sold by Lorenzo and Giuliano to the Signory of Florence.

■ The detail of this figure, which is isolated both from the rest of the picture and from the adoring crowd, indicates that it might be a self-portrait of Leonardo, based on the bronze model by Verrocchio.

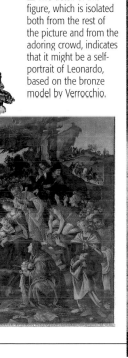

■ Above: Filippino Lippi, *Adoration of the Magi*, 1496, Galleria degli Uffizi, Florence. Because of Leonardo's departure for Milan the work remained unfinished. The commission was entrusted to Filippino, who, with Botticelli's version in mind, duly completed the work begun by Leonardo.

■ Leonardo, *Perspective Study for the Adoration of the Magi*, c.1481, Gabinetto dei Disegni e delle Stampe, Galleria degli Uffizi, Florence. The pagan architecture symbolically encapsulates the collapse of the ancient world at the moment of the Incarnation.

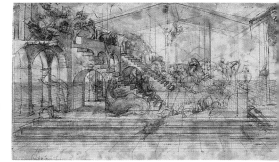

1482–1499

At the the court of
Ludovico il Moro

The letter

Leonardo, who was received in Milan as cultural ambassador of the Signory of Florence, sent Duke Ludovico a letter of introduction that listed his abilities and his extraordinary range of interests. The dukedom was going through a period of expansion and appeared to offer him opportunities he could not realize in Florence. Skilled in the crafts of peace and war, he enumerated ten points that qualified him as an engineer of war machinery and a technical adviser: a builder of "very light and strong" bridges, "cannon, mortars, and light ordnance, of very beautiful and useful shapes, quite different from those in common use", "armored cars, safe and unassailable". He only casually mentioned his artistic talents "in the construction of buildings both public and private", painting and "sculpture in marble, bronze, or clay". The letter concluded by offering to build the equestrian monument to the head of the "illustrious house of Sforza", Francesco.

■ Leonardo, *Lute Made from a Horse's Skull*, Manuscript B, Institut de France, Paris.

■ Leonardo, *Rain of Cannonballs*, Codice Atlantico, Biblioteca Ambrosiana, Milan.

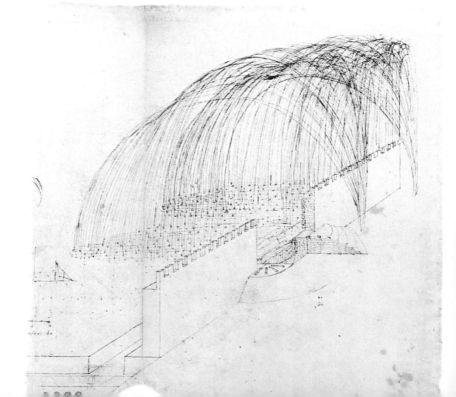

■ Leonardo, *Hats, Ribbons and Objects for Masquerades*, c.1494, Forster Codex III, Victoria and Albert Museum, London. The three small Forster codices contain various papers, differing in subject and date; the third (1493–96) was used by Leonardo to collect tables, receipts, epigrams, masks, studies for the *Sforza Monument*, other pieces of architecture, and ideas for town planning.

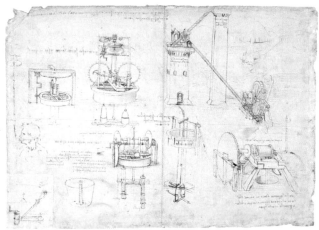

■ Leonardo, *Study of Hydraulic Instruments*, c.1480, Codice Atlantico, Biblioteca Ambrosiana, Milan. The Codice Atlantico, the most comprehensive collection known of Leonardo's manuscripts — 550 of them assembled into a single volume in the late 16th century — covers forty years' work on mechanics, mathematics, astronomy, physical geography, botany, chemistry, and anatomy.

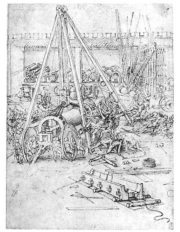

■ Leonardo, *Cannon Foundry*, Royal Library, Windsor. The development of firearms stimulated technical innovations.

■ Leonardo, *Study of War Machines*, Biblioteca Reale, Turin. The scythes attached to the chariots hack at the limbs of enemy soldiers.

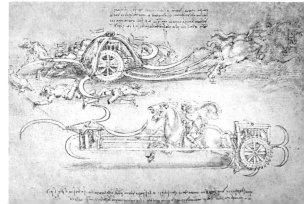

Milan, the Sforza capital

Under the rule of a genuine Renaissance prince, Ludovico Sforza, from 1480 to 1499, the political and economic achievements of the duchy of Milan were matched by its artistic and cultural accomplishments. Ludovico's assiduous diplomacy earned him the support of Alexander VI and the Emperor Maximilian of Habsburg, and led to family links with the houses of Aragon and Este. Establishing a political balance with Florence, Venice, and papal Rome, Ludovico, on the death of Lorenzo the Magnificent, was the most influential statesman in Italy. In the late 15th century Milan invested vast amounts of capital into land reclamation and canal-building, and expanded the cultivation of mulberries, flax, and rice, which were exported abroad together with arms, glass, textiles, and agricultural products. On the cultural front, Ludovico, an enterprising patron, received at his court humanists such as Filelfo, Calcondila, and Facio, and promoted the new art of printing with Panfilo Castaldi of Feltre and Antonio Zaroto of Parma.

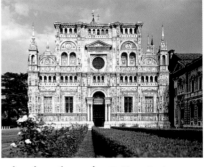

■ Giovanni Antonio Amadeo and Benedetto Briosco, *Certosa di Pavia*, Pavia. The charterhouse, a Carthusian monastery, housed the Visconti library.

■ *Sforza Castle*, Milan. Rebuilt in the late 19th century by Luca Beltrami, the castle, which contains the remains of the ancient Visconti stronghold, was built on a plan by Filarete. The Filarete tower probably collapsed in 1521.

■ Sforza armorial bearings, Teodolinda Chapel, Cathedral, Monza. The house's heraldic device of the snake alternates with the Sforza coat-of-arms.

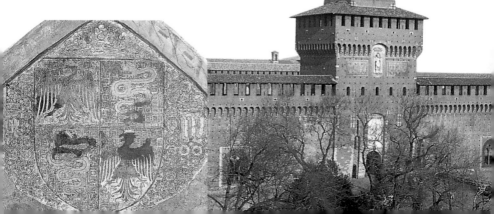

■ Leonardo, *Emblem of the Sforza*, Manuscript H, Paris notebook, Institut de France, Paris. In the codex compiled between 1493 and 1494, which contains studies of river water, mechanical and hydraulic apparatus, notes on grammar, studies of animals, and allegories, a corner is reserved for a homage to the ducal heraldry. Renaissance courts, including that of the Sforza, showed a keen interest in the universe of symbols, allegories, and mottoes. The mural paintings of the *Last Supper* and the *Sala delle Asse* testify to the fact that Leonardo shared this view.

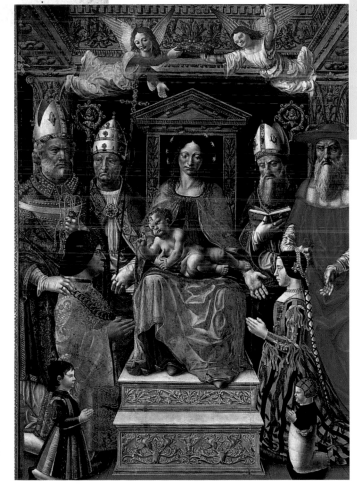

■ Master of the Sforza Altarpiece, *Sforza Altarpiece*, c.1494, Brera, Milan. The altarpiece, a kind of political manifesto of Sforza rule, and originally in the church of Sant'Ambrogio at Nemus, shows Ludovico and his wife Beatrice d'Este kneeling at the feet of the Madonna and Child and the four Doctors of the Church. The exaggerated Leonardesque style testifies to the classical tastes of court culture. The awkwardness of the figures and the over-elaborate ornamentation create, overall, an excessive effect.

Contributions from central Italy

The classical inclination of Lombard art was particularly pronounced during the second half of the 15th century. The central event was the arrival of the Urbino-born Donato Bramante, already a pre-eminent figure of the local Renaissance. Together with the Sienese Francesco di Giorgio Martini, also well-versed in the teaching of Brunelleschi and Alberti, he introduced the modern principles of illusory perspective both in painting – the *Men at Arms* in the Casa Panigarola – and in architecture – the choir of San Satiro and the majestic tribune of Santa Maria delle Grazie. But even before this, a number of architect-sculptors from central Italy were making their mark on the development of the visual arts. On the recommendation of Piero de' Medici, Antonio Averulino, known as Filarete, came to Milan in 1451 to work on the Sforza Castle, together with his contemporaries Benedetto Ferrini and Jacopo da Cortona. Later the work of Michelozzi Michelozzo enriched local culture with motifs based on Ghiberti and Donatello, in an invigorating revival of subjects from antiquity.

■ Michelozzo, *Portal of the Medici Bank*, 1462–68, Sforza Castle, Milan. This portal, carved with motifs based on the typology of antique triumphal arches, is the only fragment to survive of the ancient building.

■ Donato Bramante, *Apse of Santa Maria delle Grazie*, Milan. At the court of il Moro, Bramante, architect, painter, engineer, poet and amateur musician, was involved in the plans for the cathedral's lantern, the cloister of Sant'Ambrogio, Pavia Cathedral, and Vigevano Castle.

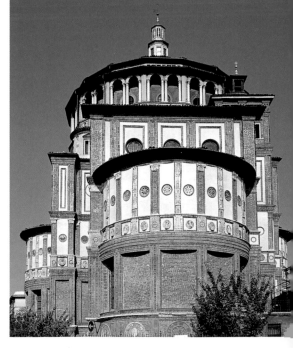

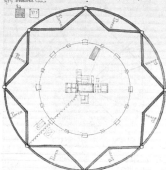

■ Filarete, *Sforzinda Project*, 1460–64, Biblioteca Nazionale, Florence. The blueprint for Sforzinda, the ideal Renaissance city, in the pattern of a star with a radiocentric plan, was contained in the 25 books of Filarete's *Treatise on Architecture*, the first theoretical treatise in the vernacular, written between 1461 and 1464. A spokesman for Tuscan Renaissance culture, Filarete nevertheless revived the late Gothic Lombard tradition.

■ Filarete, *Sforzinda Project*. Filarete was the planner of a palace for the Sforza on the Grand Canal in Venice. In Milan he was active in the cathedral workshop, collaborated on the Sforza Castle, and designed the Ospidale Maggiore. The Sforza commissioned the him to devise a plan for a modern and grandiose capital city.

Northern artists at court

The cultural life of Milan was not as concentrated as that of Florence, nor was its system of artistic production so advanced. Still receptive to Northern ideas after the decline of International Gothic, and still reliant on the medieval-style organization of skilled labor, the duchy was open to a variety of outside influences, ranging from the Veneto to Liguria and into Provence, fusing them with indigenous styles. There are echoes of Ferrara in the sharply etched features of Butinone's painting and in the sculpture of the Mantegazza brothers, whereas the effects of Flemish art are evident in the work of Donato de Bardi and Zanetto Bugatto, who were sent to Brussels by Bianca Maria Sforza. The former, a Pavian who emigrated to Genoa, had a determining influence on Foppa, pioneer of the Renaissance in Lombardy who blended the perspective principles of Tuscany and Padua with a naturalism wholly in accord with Lombard taste. There was a similar quality to the tranquil, uniform style of Bergognone, who painted in the Certosa of Pavia.

■ Ambrogio Bergognone, *Madonna and Child*, c.1490, Accademia Carrara, Bergamo. Possibly a pupil of Bugatto, Bergognone brought more than topographical detail, indeed spiritual insight, to his rendering of the Lombard landscape.

■ Zanetto Bugatto (?), *The Cagnola Madonna*, c.1470, Fondazione Cagnola, Gazzada. The painter was sent to Brussels to gain specialized experience in the workshop of Rogier van der Weyden.

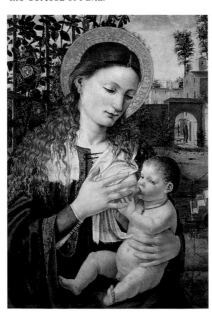

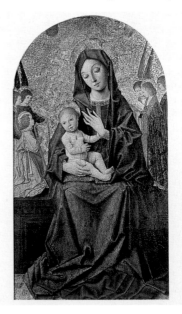

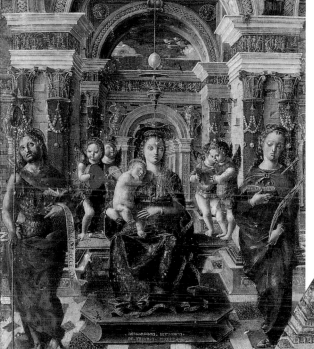

■ Bernardino Butinone, *Madonna with Angels and Saints*, c.1485, Collezione Borromeo, Isola Bella. Although they had distinct individual styles, Butinone and Zenale jointly took on the commissions of the *Treviglio Polyptych* (Bergamo) and that of the *Grifi Chapel* of San Pietro in Gessate, Milan.

■ Andrea Fusina, *Funeral Monument of Bishop Bagaroto*, Sforza Castle, Milan. Employed both in the Certosa of Pavia and Milan Cathedral, Fusina brought to his sculptures a decorative classical taste in the Venetian style.

■ Vincenzo Foppa, *Annunciation*, 1468, Portinari Chapel, Sant'Eustorgio, Milan. An authoritative reference point for the painting of the 1470s, Foppa's painting was founded upon a repertory of classical inspiration, interpreted with an acute sensitivity to the values of chiaroscuro.

The Virgin of the Rocks

Together with the da Predis brothers, Leonardo was involved in the decoration of the polyptych for San Francesco Grande. Linked to the iconography of the Immaculate Conception, the painting (now in the Louvre) evokes an episode of the apocryphal Gospels.

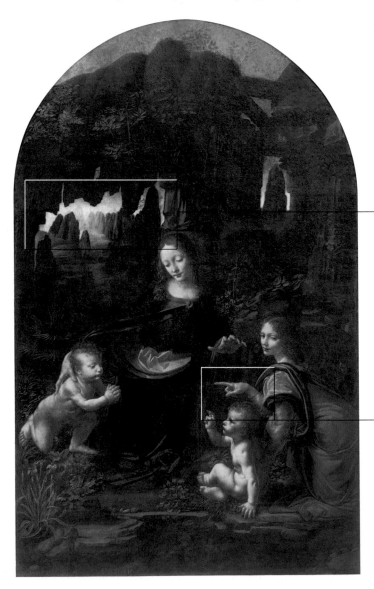

■ A second, later version in London's National Gallery is framed by the *Musician Angels* of Marco d'Oggiono and Ambrogio da Predis. The central panel (c.1495–1508), completed by da Predis, was probably done under Leonardo's supervision.

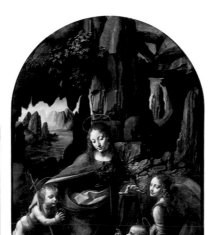

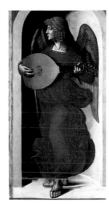

■ The sacred drama is enveloped in the shadows of a dank cave. Irregular clefts in the walls of the dark cluster of rocks throw a receding light on the jagged pinnacles of rock in the distance, heightening the the plastic relief of the figures in the foreground.

■ The hand of the angel Uriel, with its finger pointing mysteriously towards St John, follows a recommendation by Alberti, and is omitted from the second version, which attempts to dispense with any element of an excessively literary nature.

The demands of court

■ Leonardo, *Longhorn Beetle and Dragonfly*, Biblioteca Reale, Turin.

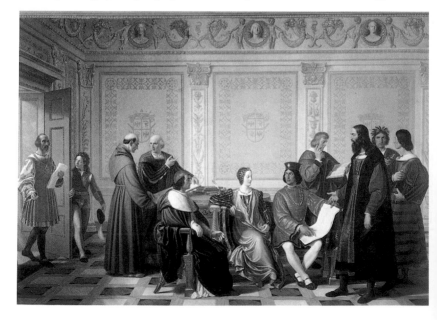

Ludovico Sforza aimed to remodel his court along classical lines of learning and culture, seeking to emulate the example of the Montefeltro at Urbino, the Medici in Florence, and the Este of Ferrara. To this end he invited the collaboration of experienced engineers such as Bramante and Leonardo, whose official duties also extended to the field of pageantry and entertainment. At the court of il Moro Leonardo alternated serious scientific research with exercises in fantasy, ranging from ideas for war machines and water "skis" to designs for heraldic emblems and costumes, the devising of maxims, jokes, and rebuses, and the organization of mathematical and allegorical parlour games. As a stage designer and musician, Leonardo helped to arrange the wedding festivities of Gian Galeazzo and Isabella of Aragon (1489), of Ludovico and Beatrice d' Este (1491), and of Bianca Maria and the Emperor Maximilian (1493). The former occasion culminated in the famous Festa del Paradiso, an allegory thought up by the Florentine poet Bellincioni.

■ Giuseppe Diotti, *The Court of Ludovico il Moro*, 1823, Museo Civico, Lodi. This depicts the most important moment of Leonardo's first stay in Milan, the commissioning of the *Last Supper*.

Geometry and proportion

Leonardo, *Proportions of the Human Figure: Frontispiece to Pacioli's De Divina Proportione* (written 1498 and published 1509), Gallerie dell'Accademia, Venice. The mathematician Luca Pacioli, a friend of Leonardo from 1496, drew upon ideas from Vitruvius' *De architectura* for an explanation of how the ancients proportioned their work in accordance with the right arrangement of the human body. Leonardo, who derived from Pacioli much of his knowledge of Euclid and geometry, illustrates how, spread-eagled, a man fits into a circle: with feet and arms outstretched, he fits into a square, the two figures considered essential for any representation.

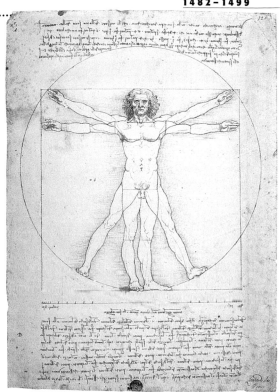

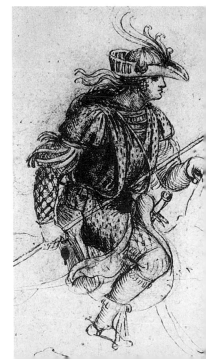

■ Leonardo, *Sketch of a Lady's Purse*, 1497, Codice Atlantico, Biblioteca Ambrosiana, Milan.

■ Leonardo, *Sketch of a Young Man on Horseback*, Royal Library, Windsor. A costume for a court tournament.

The Sforza Monument

Inspired by Donatello and Verrocchio, the colossal bronze equestrian monument to Francesco Sforza was never finished. The statue occupied Leonardo for more than 16 years. The terracotta model was destroyed by the crossbowmen of Louis XII.

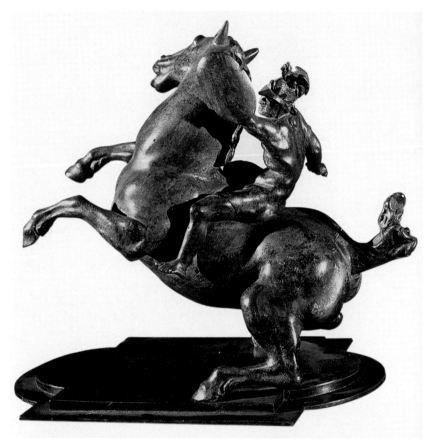

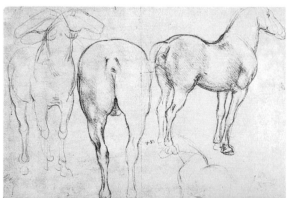

■ Lombard sculpture, *Equestrian Statue*, model in bronze, Szépmüvészeti Museum, Budapest.

■ Leonardo, *Study of Horses from Life*, Royal Library, Windsor.

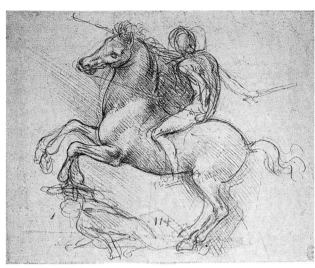

■ Leonardo, *A Horseman Trampling a Fallen Foe*, 1483–84, Royal Library, Windsor. This study of Francesco mounted on a horse trampling a defeated enemy shows a measure of formal idealization that Leonardo could have derived only from classical models, known to him at the time from his frequent visits to the Medici collections.

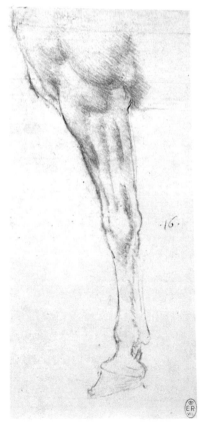

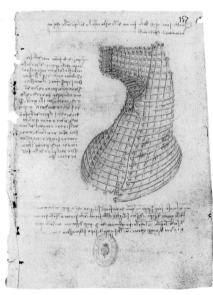

■ Leonardo, *Study of a Horse's Leg*, 1493, Royal Library, Windsor. The monument offered Leonardo the chance to work out a systematic scheme of comparative anatomy, based on studies of the horse's proportions and movements.

■ Leonardo, *Study of Mould for Casting the Horse's Head*, 1491–93, Madrid Codex II, Biblioteca Nacional, Madrid. Because of the statue's size, almost 7.2 metres (23 feet) high, Leonardo designed the cast in pieces.

Architect, town-planner, technologist

■ Leonardo, *Plan for Santa Maria in Pertica at Pavia, a Theatre for Hearing Mass, and an Amphitheatre within the Plan of San Lorenzo Maggiore*, Manuscript B, Institut de France, Paris.

Milan offered Leonardo the opportunity to investigate problems of military and civil engineering, the mechanics of fluids, acoustics, ballistics, optics, and statics. In addition to tackling the specific problems of individual clients, as a theoretician and man of science he developed his general thinking on the concepts of force, weight, movement, and percussion. Only after 1500 did he gradually lose interest in designing machines and devote his attention primarily to studying the nature of water. Alongside his analysis of the human body he intensified his research into natural features and phenomena such as mountains, valleys, and earthquakes. Leonardo's logic was inductive, using individual example as a departure point in the quest for a universal principle. He improved upon contemporary engineering projects like those of Francesco di Giorgio and Brunelleschi, motivated by Pacioli and his familiarity with the classical and contemporary texts to which he had access during his stay at the Sforza court. He also designed spinning frames, throwing and doubling machines, mechanical looms, and grinding devices for files and needles. This vision of technology, in which utility and beauty were inseparable, and which also applied to architecture, complemented the workings of the natural world.

■ Leonardo, *Design for a Rolling-mill*, Manuscript G, Institut de Paris, Paris. Textiles and military supplies were the two principal industries of Milan at this time, and ideas for innovations and improvements were eagerly sought.

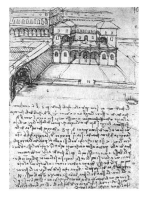

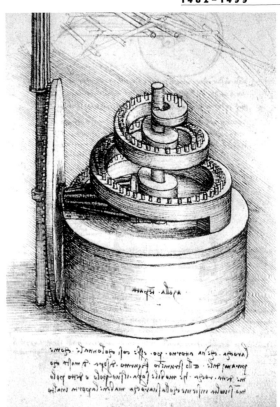

■ Top: Leonardo, *Sketch of a Stable for Vigevano*, Manuscript B, Institut de France, Paris.

■ Above: Leonardo, *Project for a City on Several Levels*, Manuscript B, Institut de France, Paris.

■ Leonardo, *Design for the Dome of Milan Cathedral*, 1487–88, Codice Atlantico, Biblioteca Ambrosiana, Milan. This project, on which Leonardo worked in conjunction with Bramante and Francesco di Giorgio, was later abandoned by the artist and finally completed by Amadeo and Dolcebuono.

■ Leonardo, *Sketch of an Appliance for Equalizing a Helical Spring*, 1494–96, Madrid Codex I, Biblioteca Nacional, Madrid. Leonardo's machines, like natural bodies, operated according to the universal laws of dynamics. Among these machines, some have proved to be workable, while others remain purely imaginary.

Faces, eloquent and grotesque

Leonardo's remarkable creative flair and modern outlook were reflected in his studies of human physiognomy, originating as a popular comic theme at court in the literary context of mottoes and jokes. Captivated by nature in all its forms, Leonardo did not shy away even from its lewd, grotesque, and bizarre aspects, its deviations and deformities, varying his catalogue of human types in relation to their anatomy, facial features, and dispositions. As he states in the Codex Urbinas: "The signs of the face partly show the nature of men, their vices and their constitutions." This art form, encompassing a broad range of moods, was a fundamental element of 15th-century secular culture. At the end of the16th century, inspired by the local Academy of the Blenio Valley, headed by the art theorist Giovanni Paolo Lomazzo, and still strongly influenced by Leonardo, grotesque images had a wide appeal among European artists, as demonstrated by the French painter Charles Le Brun (17th century) and the German sculptor Franz Xavier Messerchmidt (end of 18th century). Later still, following the discovery of the unconscious, Leonardo's grotesque fantasies proved to be valuable in the context of the treatment of psychopathic abnormality and the development of psychoanalysis.

■ Leonardo, *An Old Man with a Prominent Chin*, 1490–95, Gabinetto Nazionale dei Disegni e delle Stampe, Galleria degli Uffizi, Florence. This sketch has been linked to Judas in the *Last Supper*.

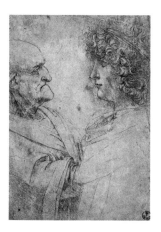

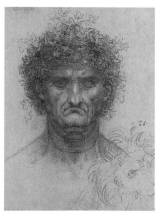

■ Leonardo, *An Old Man and a Youth Facing One Another*, c.1495, Codice Trivulziano, Biblioteca del Castello Sforzesco, Milan.

■ Leonardo, *An Old Man Wearing an Ivy Wreath*, Royal Library, Windsor.

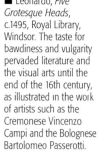

■ Leonardo, *Five Grotesque Heads*, c.1495, Royal Library, Windsor. The taste for bawdiness and vulgarity pervaded literature and the visual arts until the end of the 16th century, as illustrated in the work of artists such as the Cremonese Vincenzo Campi and the Bolognese Bartolomeo Passerotti.

■ Leonardo, *A Man and a Woman Facing Each Other*, 1487–90, Royal Library, Windsor.

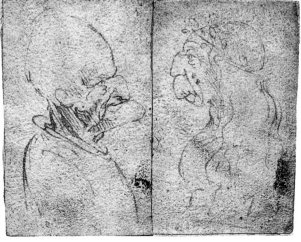

■ Leonardo, *Sketch of Three Figures in Profile*, c.1495, Gabinetto dei Disegni e delle Stampe, Galleria degli Uffizi, Florence.

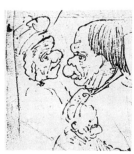

The Last Supper

Begun between 1494 and 1495 and completed after years of intermittent work, the *Last Supper* (c.1498) on the wall of the refectory of Santa Maria delle Grazie in Milan represents the Eucharist scene at the moment of the announcement of Judas' betrayal.

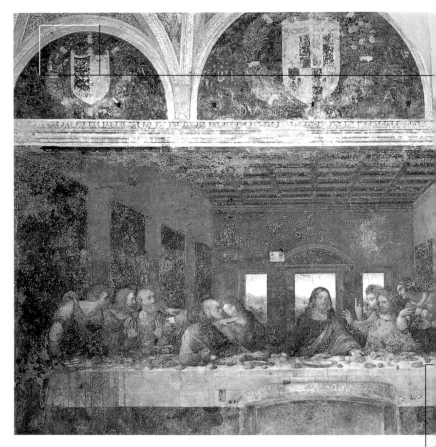

■ A still life on a tablecloth. Restoration, almost completed, has eliminated the repainting and reinstated the brilliant colors, the well-modelled forms, and the chiaroscuro tones. In this way the extraordinarily realistic nature of the painting has been recaptured.

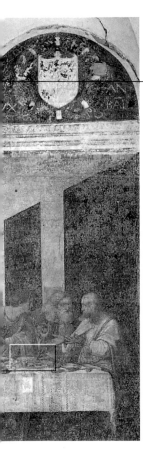

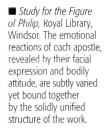

■ Details of the garland for the Sforza crest. The three lunettes painted *a secco* were brought to light in 1854. They combine the crests of Ludovico, Duke of Milan, Beatrice d'Este, and their two sons, the Counts of Pavia and Bari.

■ *Study for the Figure of Philip,* Royal Library, Windsor. The emotional reactions of each apostle, revealed by their facial expression and bodily attitude, are subtly varied yet bound together by the solidly unified structure of the work.

■ *Study for James the Greater,* Royal Library, Windsor. The gestures and features of the apostles, rhythmically arranged in groups of three, and differentiated by age and character, are linked by the visible symptoms of anxiety caused by the words of Christ.

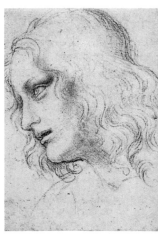

The science of painting

■ *Apocalyptic Vision*, c.1517, Royal Library, Windsor. Leonardo imagined the end of the world either through flooding or absolute drought.

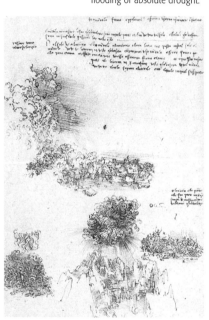

"**I**f you wish to see the beauties which stir the painter, he is the master who generates them; if you wish to see the monstrous things that terrify him, or which are clownish and laughable, or truly deserving of compassion, he is their master and creator;…he can depict cool, shady places in hot climes or hot places in cold climes …whatever is essentially in the universe, real or imagined, first it is in his mind and then in his hands." (Codex Urbinas.) Never had the responsibility of the painter been so great, nor his work fraught with such tension. For Leonardo, painting was the supreme art, superior to sculpture, music, and poetry, the summation of all knowledge conceded to man. It stood on an equal footing with natural philosophy, well-suited to investigate the appearance of things and the hidden causes behind them. Every aspect of reality and imagination was capable of being represented, and the potential scope of art was thus infinite.

■ *Study of Flowers for the Leda*, 1508–10, Royal Library, Windsor. Leonardo's astonishing diversity of interests ranged from physiology to mathematics, from geometry to optics, from mechanics to military engineering and hydraulics, and from botany to geology.

■ *Study of Light and Shadow on a Robinia,* c.1508, Royal Library, Windsor. For Leonardo painting was the interpretation of nature: "The painter must transmute nature in his mind and interpret it in such a way that it is both nature and art."

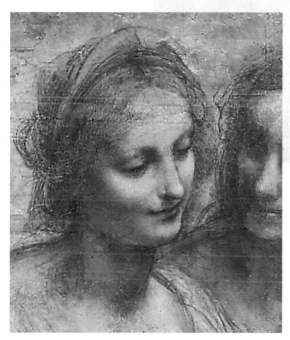

■ Detail of the face of Mary in the cartoon for *St Anne*, National Gallery, London. In accordance with Neo-Platonic thinking, Leonardo often presented beauty as a lovable quality. The concept is evident in this strikingly feminine portrait.

■ *Study of an Old Man,* 1490–95, Gabinetto Nazionale dei Disegni e delle Stampe, Rome. "A man must be drawn in proportion, whether he is short and fat or tall and thin; and anyone who takes no heed of such variety deserves severe rebuke."

The Renaissance portrait

A characteristic genre of Renaissance culture, portrait painting was exercised by the problems of naturalism and was also in many ways indebted to classical art. The renewed interest in individual physiognomy, already evident in the 14th century, re-emerged even more forcibly in the latter half of the 15th century with the revitalization of ancient archetypes and the achievements of Flemish painting. The archaic tradition of numismatic potraiture, still in vogue in fifth-century Italy, gave way to a radical change of approach, introduced by Antonello da Messina and Leonardo, in a synthesis of Italian and Flemish styles. Both artists derived the half- and three-quarter-length portrait from Northern example, which Memling took further by setting the image of the subject against a naturalistic background.

■ Below left: Giorgione, *Self-Portrait*, c.1505, Herzog Anton Ulrich Museum, Braunschweig. The "shoulder-length portraits" of Giorgione suggest a close link between Leonardo and the Venetian artist.

■ Below: Antonello da Messina, *Trivulzio Portrait*, 1473, Museo Civico, Turin. The artist registers the facial features and character of his subjects, as well as representing the three-dimensional values.

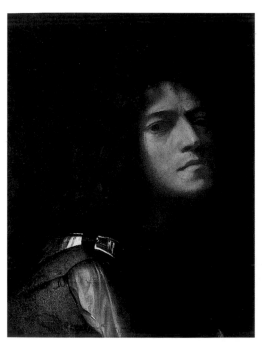

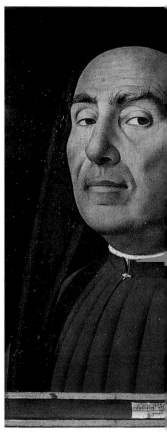

■ Raphael, *Portrait of Baldassar Castiglione*, 1514–15, Musée du Louvre, Paris. The composition of this portrait owes much to the example of Leonardo's *Mona Lisa*. Raphael's painting of the celebrated court poet was to be imitated repeatedly in the following centuries; both Rubens and Rembrandt made important copies of it.

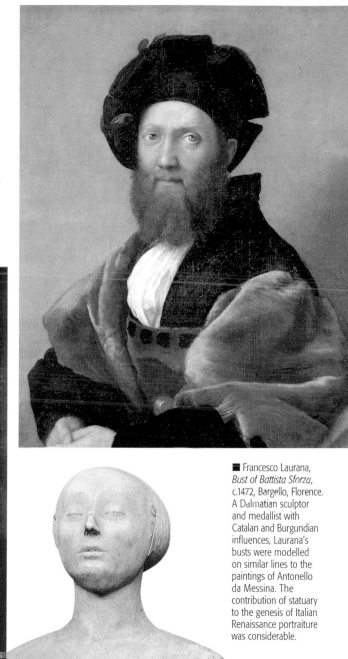

■ Francesco Laurana, *Bust of Battista Sforza*, c.1472, Bargello, Florence. A Dalmatian sculptor and medallist with Catalan and Burgundian influences, Laurana's busts were modelled on similar lines to the paintings of Antonello da Messina. The contribution of statuary to the genesis of Italian Renaissance portraiture was considerable.

63

1482–1499

Leonardo's Milanese portraits

Leonardo's portraits mark a decisive turning point in the evolution of the genre. Trained in a sculptor's workshop, he profited from the tuition and example of Verrocchio, which stressed the plastic qualities of form and the dual interaction of the figure with the spectator, as well as with the surrounding space. After his debut in Florence with the portrait of *Ginevra de' Benci*, still somewhat static and waxen, Leonardo had the chance to try out new ideas in Milan. This was the period of the allegorical likenesses of *Cecilia Gallerani* and *Lucrezia Crivelli*, mistresses of il Moro, and of the *Musician*. In these he set the figure, illuminated by different sources of light, against a neutral background in shadow, derived from the examples of Antonello (working in Milan in 1475). Whereas the *Musician*, the only male portrait, is distinctive for an air of gentle stillness and "metaphysical" abstraction, a sense of suspended action and profound mental occupation, the portraits of the two women are notable for the dynamic role of the light that accentuates the rotational movement activated by the shoulder. The tendency towards a spiral-shaped structure that emerges clearly in Leonardo's three Milanese portraits was subsequently taken a step further by Mannerist painting and sculpture of the so-called "serpentine figure".

■ Leonardo, *Cecilia Gallerani*, c.1490, Czartoryski Museum, Cracow. Analysis of the painting under X-ray has revealed the presence of an open door in the background. The choice of ermine (γαλῆ in Greek), symbol of virginity and perspicacity, alludes to the name of the sitter, whose luminous physical beauty has no erotic connotations.

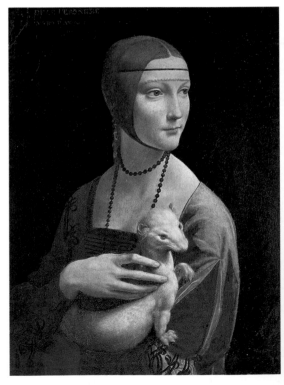

■ Leonardo, *La Belle Ferronnière*, 1490–95, Musée du Louvre, Paris. This portrait has been identified as that of Lucrezia Crivelli. The asymmetrical pose of the woman, perhaps originally balanced by an architectural element on the left, induces the spectator to move around the image, almost as if it were a sculpture. The interaction of form and light reinforces the dynamic effect. Having by now mastered these two structural elements, Leonardo here surpasses the experimentalism of the *Benois Madonna*.

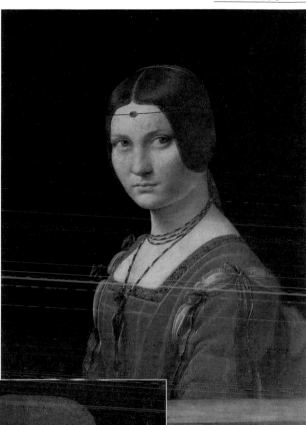

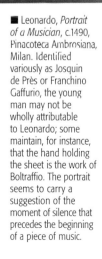

■ Leonardo, *Portrait of a Musician*, c.1490, Pinacoteca Ambrosiana, Milan. Identified variously as Josquin de Près or Franchino Gaffurio, the young man may not be wholly attributable to Leonardo; some maintain, for instance, that the hand holding the sheet is the work of Boltraffio. The portrait seems to carry a suggestion of the moment of silence that precedes the beginning of a piece of music.

1482–1499

The Sala delle Asse

In 1498 Leonardo decorated the north-east room of the Sforza Castle with a painting depicting clusters of rock out of which grow eighteen huge trees. The branches of the trees rise from the walls to form a broad canopy, leaving only some patches of sky visible. A rope of golden knots intertwines with the foliage, the composition culminating in the centre of the vaulted ceiling where the Sforza ducal coat-of-arms appears. The naturalistic design has been seen by some as a symbolic depiction of the valley of Tempe, *locus amoenus* of classical literature.

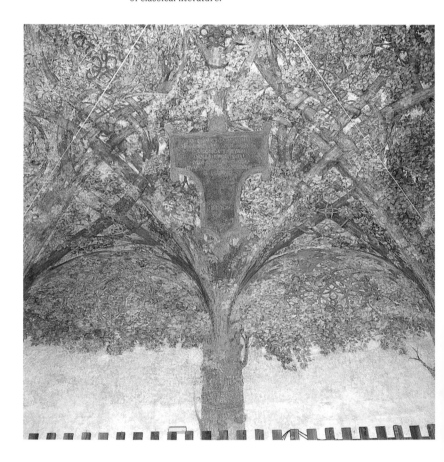

■ *Plinth with Rocks and Roots,* North Wall. Revealed with the rest of the decoration after the restoration (1893–94), these monochrome images were spared the repaintings of 1901–02. Concealed by wooden boards until 1954, they offer a glimpse of the continually conflicting forces of nature.

■ *Sforza Bearings on the Ceiling in an Arabesque of Black Mulberry Branches.* The mulberry (a symbol of prudence and wisdom) is a metaphor for the government of Ludovico, depicted here in a jagged, unrepeating geometrical pattern. The mulberry also alludes to the power of il Moro.

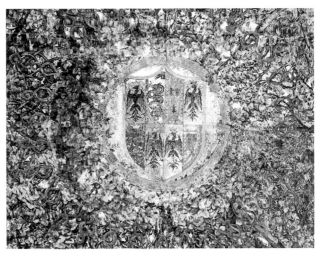

■ Engraving from the Vincian Academy, c.1495, Biblioteca Ambrosiana, Milan. The knots, an emblem of Leonardo himself, are in keeping with the decoration of the room. The Sala delle Asse was possibly intended as a meeting place for cultural events.

■ The Dürer version (1507) is an important document of Renaissance graphic art.

BACKGROUND

Mantua, Venice, and the Romagna

In 1499, Louis XII, reaffirming sovereignty over Milan, invaded the duchy. Il Moro attempted a comeback but, defeated at Novara in 1500, died an exile in France. At that time Leonardo left as well. First he went to Venice, which, in 1500 was under threat by the Turks, and sought his advice on military matters. He then turned to the Mantuan court of Isabella d'Este, the daughter of Eleonora of Aragon and the mother of Francesco Gonzaga. The marchioness commissioned the painting of a *Madonna* for her private study, a *Twelve-year-old Christ*, and a half-length portrait of herself which was never to be completed. After his journey to Venice Leonardo returned to the Este court as an architect and to advise on the purchase of items for the court collection. Between 1502 and 1503, perhaps as secret agent of the Republic alongside Machiavelli, he visited the Romagna with Cesare Borgia and then accompanied the latter to Piombino.

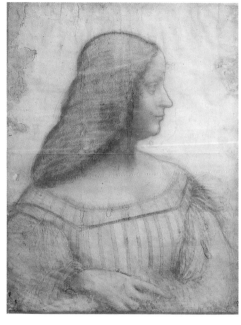

■ Leonardo, *Cartoon for the Portrait of Isabella d'Este*, c.1500, Musée du Louvre, Paris. Connected with the medal of Gian Cristoforo Romano (1498), the cartoon, reflects the style of archaic medal portraiture. The austerity of the head is modified by the movement of the bust.

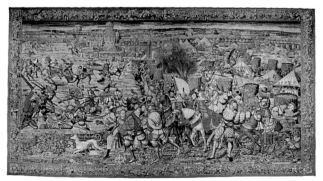

■ *The Battle of Pavia*, Capodimonte, Naples. The battle (1525) ended in the defeat of France.

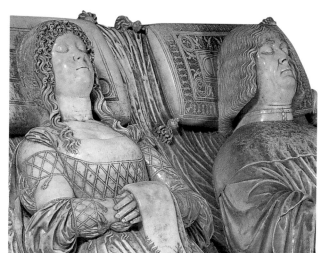

■ Cristoforo Solari, *Funeral Monument to Ludovico il Moro and Beatrice d'Este*, Certosa, Pavia. The tomb statues originally created by the Lombard sculptor to be placed in Bramante's tribune of Santa Maria delle Grazie were transferred to the Certosa in Pavia in 1564.

■ Andrea Mantegna, *Parnassus*, 1497, Musée du Louvre, Paris. Together with the *Triumph of Virtue*, Mantegna painted this large canvas for the *studiolo* of Isabella d'Este. Educated by Guarino Guarini and other famous humanists, the marchioness, a scholar and writer, had contacts with Baldassare Castiglione, Matteo Bandello, Ludovico Ariosto, Matteo Maria Boiardo, Pietro Bembo, and Gian Giorgio Trissino.

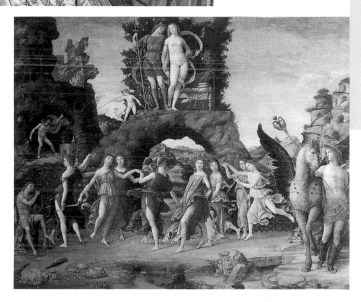

■ Bernardino Luini, *Jesus Among the Doctors*, first decade of 16th century, National Gallery, London. Probably a copy of the painting which Isabella commissioned from Leonardo, this work is notable for the shift in the axes of the composition: Christ is not teaching the apostles but addresses us as spectators. This device, previously adopted by Antonello da Messina in his *Virgin of the Annunciation*, was to be repeated by Leonardo in his *Angel of the Annunciation*. With this direct involvement of the observer, Leonardo's conception appears more radical than the conventional approach of Antonello.

Leonardo, military engineer

■ Leonardo, *Polygonal Bulwark*, c.1502–03, Codice Atlantico, Biblioteca Ambrosiana, Milan. The drawing shows a fortress bounded by a ditch and two concentric enclosures.

Leonardo's interest in architecture and military engineering determined the course of his travels and the nature of his activities on several occasions. His knowledge of war machines, cannons, assault carriages, and siege procedures, of which he boasted in his famous letter to Ludovico, found practical application when, after the fall of the duchy, Leonardo journeyed to Venice as the Republic's military adviser. These same duties took him to central Italy with Cesare Borgia (1502–03) and then to Piombino (c.1504). As a military engineer, Leonardo built on the concepts of Brunelleschi, Taccola, Francesco di Giorgio, and Valturio. After the revolutionary introduction of firearms, he designed an array of weapons for use on land and sea, demonstrating their capabilities with ballistic experiments to increase the range of fire and speed up the loading and firing of mortars, also inventing weapons such as multi-barrelled cannons, projectiles, and exploding bombshells.

■ *Plan of the City of Imola,* before 1474, Royal Library, Windsor. This celebrated drawing is not attributable to Leonardo, who is credited only with the additions (1502–03), but to Danesio Maineri.

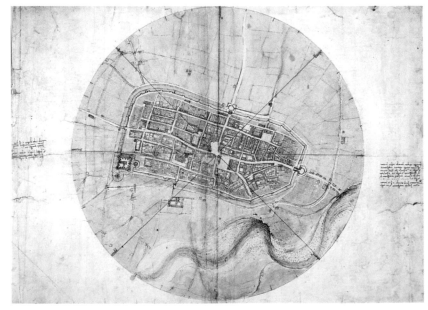

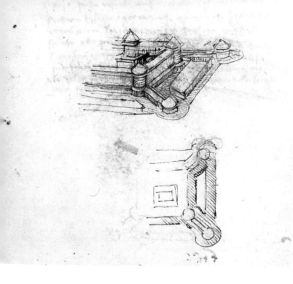

■ Leonardo, *View of a Fortress*, c.1504, Madrid Codex, Biblioteca Nacional, Madrid. This quadrangular fortress with cylindrical turrets connected to lunettes is no longer identified with the Sforza Castle in Milan. The project for the fort was in fact derived from Francesco di Giorgio.

■ Leonardo, *Star-shaped Bastion with an Indication of the Gun Embrasures Turned Towards a Circular Inner Courtyard*, 1502–03, Codice Atlantico, Biblioteca Ambrosiana, Milan. After the downfall of the Sforza dynasty and the increase in the production of artillery devices, traditional defensive systems were reviewed. The bastions were introduced in order to replace the now largely obsolete corner towers of castles and fortresses.

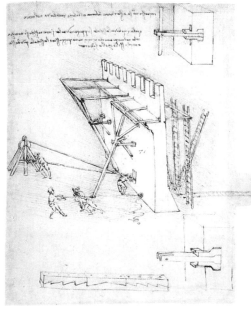

■ Leonardo, *Device for Repelling Scaling Ladders*, c.1480, Codice Atlantico, Biblioteca Ambrosiana, Milan. Leonardo studied new systems of defence, both active and passive, according to the military requirements of the court of Ludovico il Moro. Many of his studies were duly readopted and developed by Michelangelo Buonarroti for the defence of Florence against the imperial army in 1527.

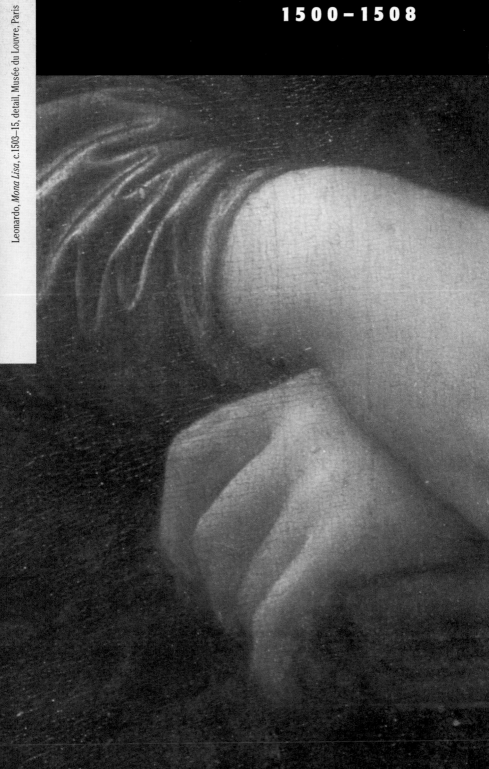

Leonardo, *Mona Lisa*, c.1503–15, detail, Musée du Louvre, Paris

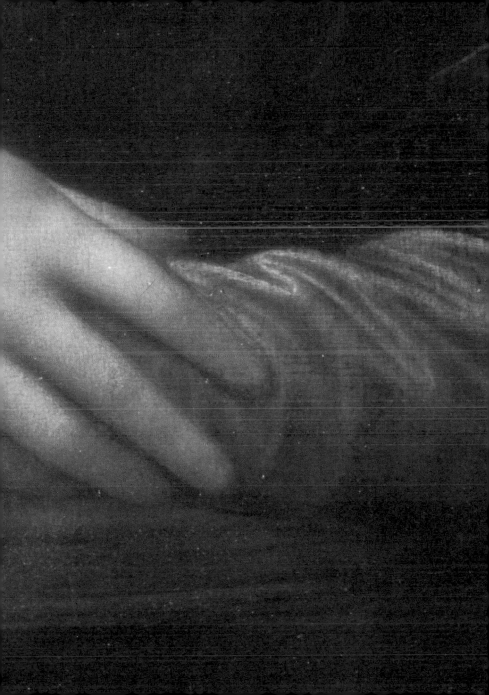

BACKGROUND

The republic of Savonarola

When Leonardo returned to Tuscany, Florence was no longer ruled by the Medici. On the death of Lorenzo (1492) the invasion of Italy by Charles VIII upset the balance of power among the Italian states. In Florence, after Lorenzo the Magnificent's son had been expelled, a Republic was proclaimed led by the Dominican monk from Ferrara, Girolamo Savonarola, previously invited by Lorenzo at the request of Pico della Mirandola. The ensuing period of social and moral austerity determined new directions in the arts: a new genre of sacred painting took hold, as practised by Lorenzo di Credi, Perugino, Mariotto Albertinelli, and Fra Bartolomeo. The late style of Botticelli also reflected the penitential overtones of the "bonfire of the vanities": abandoning his classical manner, the painter turned with growing emotionalism to religious and allegorical subjects, breaking up compositional rhythms and exaggerating figurative gestures. Excommunicated by Alexander VI Borgia in 1497 as "the instrument of the devil and ruin of Florence", Savonarola was burned at the stake the following year in the Piazza della Signoria. The event is commemorated by a pavement inscription.

■ Giovanni delle Corniole, *Savonarola*, Museo degli Argenti, Pitti Palace, Florence.

■ Anonymous 19th-century artist, from a late 15th-century painting, *The Execution of Savonarola*, Galleria Corsini, Florence. Among Savonarola's writings were the poems *De ruina mundi* (1472) and *De ruina ecclesiae* (1475), the *Trattato divoto e utile delle umiltà* (1491), the *Trattato dello amore di Cristo* (1492), the *Libro della vita viduale* (1495), and the *Triumphus crucis*, published in Latin and in the vernacular (1497).

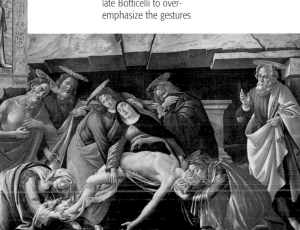

■ Sandro Botticelli, *Pietà*, c.1495, Alte Pinakothek, Munich. This painting, from the Florentine church of San Paolino, is an example of the tendency of the late Botticelli to over-emphasize the gestures and expressions of his figures; by this time the influence of Savonarola had alienated Botticelli from Neo-Platonic and humanist culture.

■ Mariotto Albertinelli, *Crucifixion*, 1506, Certosa del Galluzzo, Florence. A pupil of Cosimo Rosselli, Mariotto ran a workshop with Fra Bartolomeo from whom he derived his taste for classical monumentality. The feeling for symmetry, the grandeur of scale, and the sensitivity to color link him to Perugino and Piero di Cosimo.

■ Fra Bartolomeo, *Tondo of Madonna and Child*, Private Collection. A prime exponent of the High Renaissance pictorial style in Florence, Baccio della Porta, known as Fra Bartolomeo, inherited from Leonardo a talent for harmoniously intertwined figures. A devoted follower of the ideas of Savonarola, and from 1500 a Dominican friar, he then formed a workshop with Albertinelli, modelling his work on Roman and Venetian examples.

1500–1508

The Battle of Anghiari

Ⅰn the hall of the Great Council Chamber of the Palazzo Vecchio, Leonardo and Michelangelo (1505–06) worked on frescoes for two monumental scenes commemorating glorious moments in Florentine history. The subjects were to celebrate the victories of Cascina (1364) and Anghiari (1440), fought respectively against Pisa and Milan. Both scenes have been lost. Michelangelo did not even begin the fresco for the former and all that remain of the cartoons are copies of the episode of the soldiers bathing in the Arno. Leonardo, who owed the commission to the advocacy of his friend Machiavelli, managed to finish the cartoons and part of the painting for the latter, but fortune did not smile on the enterprise. His method, adopted from Pliny, involved using a kind of stucco as an alternative to fresco, on the lines of that already used for the *Last Supper*. However, the painting started to run and crumble, and all trace of it was lost by 1563, when Vasari frescoed the hall. Of the original work only partial copies remain; as do Leonardo's own invaluable sketches of skirmishes and single heads.

■ Peter Paul Rubens, *The Battle of Anghiari*, (copied from Leonardo), Musée du Louvre, Paris. Leonardo envisaged the scene as a furious struggle of men and horses around the standard, in a grand, heroic style. It was not an historical narrative but a symbolic representation of the violence and passion of war, defined by Leonardo himself as "insane and bestial madness".

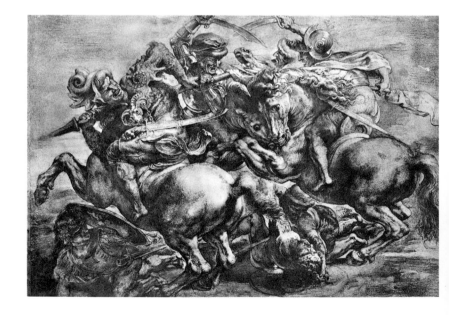

■ Leonardo, *Study of the Head of a Warrior for the Battle of Anghiari*, c.1504, Szépmüvészeti Museum, Budapest.

■ Leonardo, *Study of the Head of a Warrior for the Battle of Anghiari*, c.1504, Szépmüvészeti Museum, Budapest.

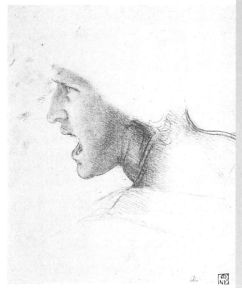

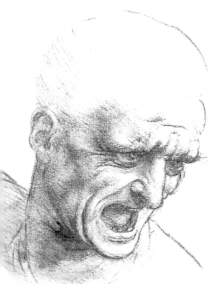

■ Aristotele da Sangallo, *The Battle of Cascina*, engraving by Michelangelo. The human figure is central to the scene and the dominant theme is the representation of the nude in movement. Michelangelo tends to "strain" the figures, exaggerating the physical, sculptural aspect, and providing a lesson in torsion and foreshortening.

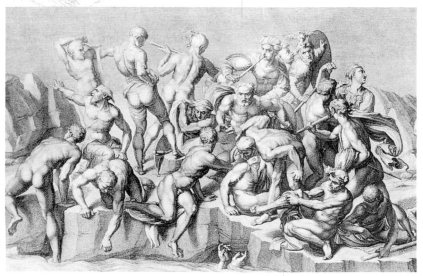

77

The first Mannerists

■ Jacopo Pontormo, *St Jerome*, c.1525–30, Niedersächsisches Landesmuseum, Hanover. Derived from the Leonardo version, this *St Jerome* is enveloped in space that lacks any perspective definition. The spatial isolation and the inwardly turned figure give psychological depth to the scene.

The background of political change in 15th-century Florence – the attempted theocracy of Savonarola, the restoration and successive downfall of the Medici, and the institution of the duchy – found echoes in the field of formal art. In place of naturalism, which had been the norm for preceding generations, there was now a move to imitate the masters of the "modern manner", Raphael, Michelangelo, and Leonardo, described by Vasari as protagonists of the "third age". Both in Italy and elsewhere in Europe, the art of Florence remained paramount, although it would soon concede primacy to the Rome of Leo X and Clement VII. Del Sarto, Rosso, and Pontormo, active almost exclusively in Tuscany, were the first to signal the historical transformation that was occurring, evident in the anti-classical taste for chromatic abstraction, in compositional diversity, and formality of pose. Yet for all their individualism, the three painters did not make any radical break with the universal principles to which they subscribed.

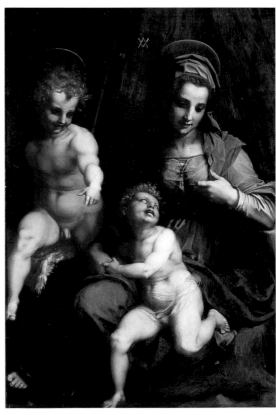

■ Andrea del Sarto, *Madonna and Child and the Young St John*, c.1505–10, Galleria Borghese, Rome. Del Sarto, who drew from Leonardo the softness of his modelling, the mobile effects of light, and certain compositional elements, opened the way to the more experimental phase of Florentine Mannerism; among his pupils were Rosso and Pontormo.

■ Franciabigio, *Madonna and Child and the Young St John (Madonna of the Well)*, c.1525–30, Galleria degli Uffizi, Florence. A fresco painter alongside Andrea del Sarto and a talented portraitist, Franciabigio was often inspired by Raphaelesque models.

■ Raphael, *Madonna of the Baldaquin*, 1507–08, Galleria Palatina, Florence. This was a fundamental reference point for the painters of this generation.

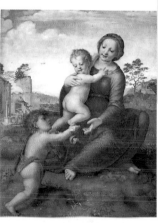

■ Giovan Francesco Rustici, *St John the Baptist Teaching*, front of the Baptistery, Florence, in place since 1511. A sculptor and painter in Verrocchio's circle, Rustici completed the bronze group under the supervision of Leonardo, with whom he shared a home for a time.

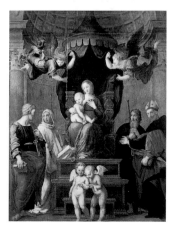

Eccentrics and Italianized Spaniards

The atmosphere of dissent and opposition that had produced Pontormo and Il Rosso also nurtured a series of strange, restless personalities, rebels by nature, whose art helped to hasten the decline of classicism. Filippino Lippi, son of Filippo and the nun Lucrezia Buti, was, like Piero di Cosimo, still wedded to 15th-century culture, but anticipated the mentality peculiar to Mannerism. A pupil of Rosselli, Piero di Cosimo was an eccentric genius who admired the naturalism of Leonardo and the Northern masters, and recoiled from idealization, even in classical scenes. During the first decades of the 16th century a number of Spanish painters visited Florence: these included Alonso Berruguete, early in his career, who on his return to Spain emerged as the most notable painter prior to El Greco; and Fernando Yañez and Fernando de Llanos, documented as collaborators with Leonardo on the *Battle of Anghiari*, who mixed typical Spanish austerity with a taste for perspective and Italianate structural novelty. Both artists continued their artistic association on returning home to Spain.

■ Piero di Cosimo, *The Conception of Mary*, after 1505, detail, Galleria degli Uffizi, Florence. Rarely seen in official circles, unconnected with the Medici environment, and frequently engaged with private commissions, Piero, a pupil of Cosimo Rosselli, responded to the influence of Leonardo, Fra Bartolomeo, and the young Raphael during the last phase of his career.

■ Fernando Yañez de la Almedina, *St Catherine*, Museo del Prado, Madrid. Yañez showed a mature assimilation of Italian motifs in the balanced monumentality of his compositions, in his confident handling of masses, and in the eloquent features of his characters, often markedly Leonardesque. In Florence he also collaborated with Pecori and the Soggi.

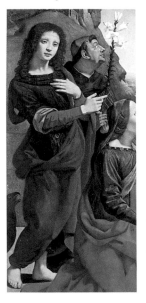

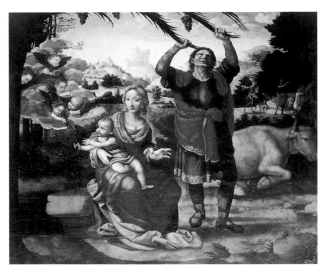

■ Filippino Lippi, *St Philip Expels the Demons*, 1502, Strozzi Chapel, Santa Maria Novella, Florence. A testament to the end-of-the-century anti-classical orientation, Filippino provides elements derived from pagan Rome in a dramatic and complex work that transforms the Gothic character of the chapel.

■ Fernando de Llanos, *Rest on the Flight into Egypt*, 1507–10, Valencia Cathedral. A methodical, diligent painter, though less creative than his contemporary Yáñez, with whom he was in Florence in the summer of 1505, Llanos painted the *Stories of the Virgin* on his return to Spain, for the retable of the high altar of Valencia Cathedral.

Studies of anatomy

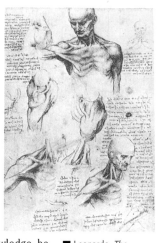

■ Leonardo, *The Muscles of the Shoulder*, c.1510–11, Royal Library, Windsor. Studies of the muscular system are always related to the conditions of motion and strength of the figure depicted.

Ever determined to explore new ways of representing truth in art, Leonardo was not disposed to learn the rules of anatomy from ancient sculpture or from second-hand sources; here, as in other fields, he demonstrated the supremacy of experience. Like other artists before and after (Donatello, Pollaiuolo, Raphael, Michelangelo, Alessandro Allori, Cigoli, Poussin, Guercino, Rubens, and Rembrandt), but surpassing them in acquired knowledge, he observed and even practised the dissection of corpses, human and animal, to which he gained access in the hospitals of Santa Maria Nuova, Florence, and Santo Spirito in Sassia, Rome. The human body provided an unrivalled opportunity for artistic and scientific analysis. His anatomical research was both topographical and physiological, with investigations carried out under normal, pathological conditions into the muscular, circulatory, and genito-urinary systems, and into the individual organs, the brain, nerves, cartilage, skin layers, and skeleton. Familiar with the anatomical writings of Galen (2nd century), of the Arab Avicenna (10th–11th century), and of Mondino (13th–14th century), he also met Marcantonio dalla Torre, the foremost anatomist of the age. The Flemish-born Andreas Vesalius, lecturer in anatomy at Padua and author of *De humani corporis fabrica* (1543), the first treatise on modern anatomy, set great store by Leonardo's studies.

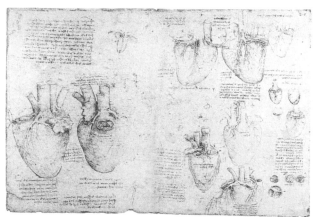

■ Leonardo, *Heart and Lungs (of Cattle)*, c.1513, Royal Library, Windsor. Studies of the heart were carried out during Leonardo's old age. The functioning of the heart and the cardiac valves was examined with the aid of glass tubes, to prevent the organ from collapsing.

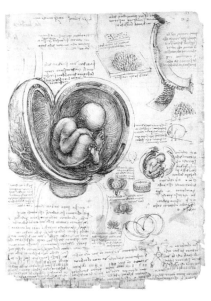

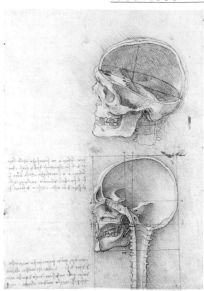

■ Leonardo, *Embryo in the Mother's Womb*, c.1510, Royal Library, Windsor. The studies on embryology, together with those on cardiology, were particularly concentrated during the Roman period (1513–16).

■ Leonardo, *Two Views of a Section of the Skull*, Royal Library, Windsor. This was one of the first studies carried out by Leonardo, who described the skull as the meeting point of the senses and the seat of the soul.

■ Leonardo, *Dissection of the Principal Female Organs and the Female arterial System, with Emphasis on the Respiratory, Circulatory, and Uro-genital Systems*, c.1508, Royal Library, Windsor.

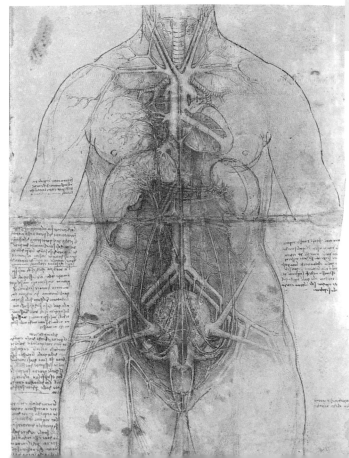

1500–1508

The cartoon for the St Anne

Probably dating from earlier than 1507, the cartoon in the British Museum, London, represents the meeting of Jesus and John in the desert. It was exhibited in Florence to an acclaim almost comparable to that of a completed work.

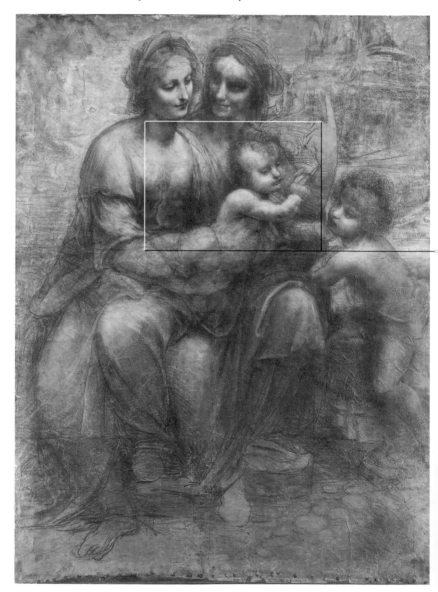

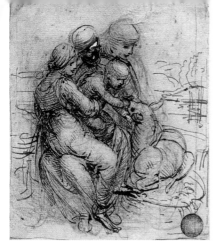

■ Leonardo, *Study for St Anne, the Madonna and Child, and the Lamb*, c.1501, Gallerie dell'Accademia, Venice. One of the fundamental pieces of advice that Leonardo gave to artists was that "fashioning the parts should not be too finished". He believed

firmly that the preliminary sketch should be a means of stimulating the mind to new forms of invention and that these preparatory exercises should be considered original creations.

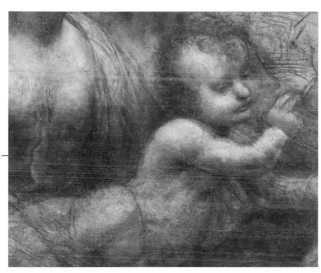

■ The Child pushes away from the arms of his mother and leans towards St John to bless him; the gesture with the diagonally outstretched arm follows the transverse path of the other figures and anticipates the Baptism The poses and gestures of the figures are linked reciprocally in a fluid and harmonious compositional rhythm.

■ Right: Raphael, *Belvedere Madonna*, 1506, Kunsthistorisches Museum, Vienna.

■ Far right: Raphael, *Canigiani Holy Family*, 1507, Galleria degli Uffizi, Florence. In this, and in the *Belvedere Madonna*, Raphael collated and developed Leonardo's notion of the pyramidal group arranged in a spiral pattern.

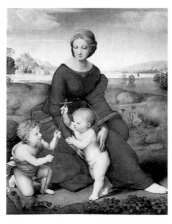

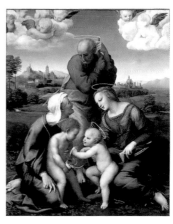

Michelangelo in Florence

Like Leonardo, Michelangelo grew up in the Florence of the Medici: a pupil in the workshop of Ghirlandaio and Bertoldo, from the start he displayed a different range of interests to his colleague and rival. Attracted by the strength in modelling form of Giotto and Masaccio, and by Donatello's classicism, he recognized in antiquity a formal and spiritual model to emulate. His approach to the classical world, familiar through the collections of the Palazzo Medici and the Neo-Platonic Accademy, was also of a literary nature. Responsive to Savonarola's preaching, Michelangelo did not share the practical and scientific ideals of Leonardo, and justified the study of anatomy only for artistic ends. Yet the lesson learned from Leonardo's cartoon for *St Anne* marked a significant development in his career, albeit later superseded by other influences. Leonardo taught Michelangelo how to organize forms within a unified structure (as is evident in the *Tondo Doni*), formally ordered motifs (the emotional agitation conveyed by the goldfinch in the *Tondo Taddei*), and the indefinable spatial and atmospheric qualities of the background (present in the first experiments of the unfinished *Tondo Pitti*).

■ Michelangelo, *Tondo Pitti*, 1503–05, Bargello, Florence. The group strains the limits of the material support.

■ Michelangelo, *Study for the St Anne*, 1501, Ashmolean Museum, Oxford. The relationship between the figures is here resolved by the clear highlighting of individual parts.

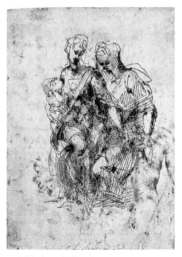

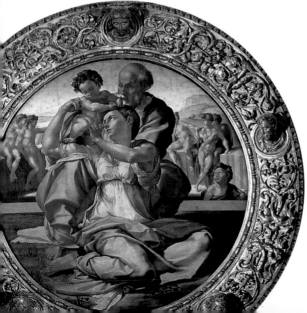

■ Michelangelo, *Tondo Doni*, 1503–04, Galleria degli Uffizi, Florence. Conceived on the lines of the model of the *St Anne*, the discords and dynamic tensions of the figures achieve perfect equilibrium.

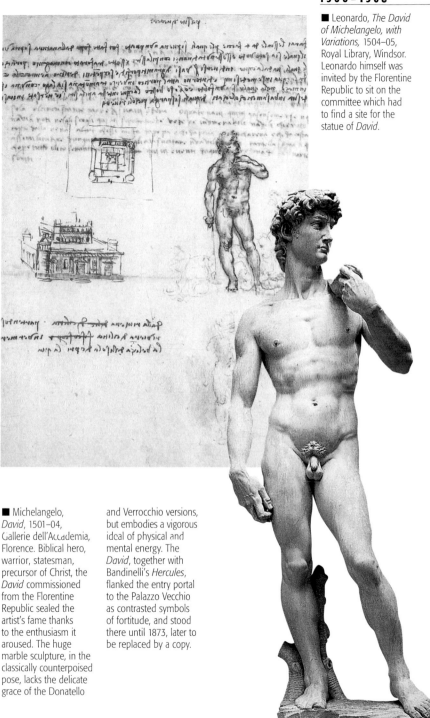

■ Leonardo, *The David of Michelangelo, with Variations,* 1504–05, Royal Library, Windsor. Leonardo himself was invited by the Florentine Republic to sit on the committee which had to find a site for the statue of *David.*

■ Michelangelo, *David,* 1501–04, Gallerie dell'Accademia, Florence. Biblical hero, warrior, statesman, precursor of Christ, the *David* commissioned from the Florentine Republic sealed the artist's fame thanks to the enthusiasm it aroused. The huge marble sculpture, in the classically counterpoised pose, lacks the delicate grace of the Donatello and Verrocchio versions, but embodies a vigorous ideal of physical and mental energy. The *David*, together with Bandinelli's *Hercules,* flanked the entry portal to the Palazzo Vecchio as contrasted symbols of fortitude, and stood there until 1873, later to be replaced by a copy.

87

1500–1508

Raphael in Florence

Having already made his mark in Urbino, working alongside his father Giovanni Santi and Perugino, Raphael was in Florence between 1504 and 1508. There he met Leonardo and Michelangelo, then engaged with their battle paintings. The interaction with the two masters was crucial to the development of the young artist, with his extraordinary gift for assimilation. Within four years he had progressed beyond the precepts learned from Perugino to reveal a new flexibility and harmony of structure. To Leonardo he was indebted for his feeling for compositional unity, the potential for emotional effect, and the sense of dramatic and narrative integrity conveyed by the flow of movement and expression. From this period came the portraits, such as those of *Angelo and Maddalena Doni*, modelled on the *Mona Lisa*, and the expansive landscapes of Memling, sacred groups such as the *Canigiani Holy Family*, formal variations on the subject of *Madonna and Child*, and altarpieces like the *Madonna of the Baldaquin*, prototype for the Florentine altarpieces of the Mannerists during the 1520s. The compositions are constructed on the pyramid pattern, with figures assembled as a single unit.

■ Raphael, *Studies for the Transfiguration*, Ashmolean Museum, Oxford. Close to completion when the painter died, the *Transfiguration* testifies to Raphael's lasting interest in the psychic vitality of Leonardo's figures.

■ Raphael, *Madonna Tempi*, 1508, Alte Pinakothek, Munich. This composition is built up on a pattern of spiral movement.

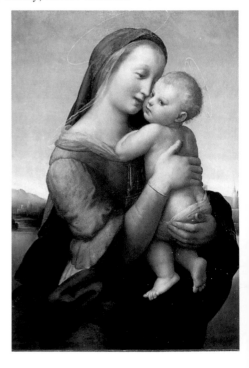

■ Raphael, *Study for the Madonna and Child*, 1518, Gabinetto dei Disegni e delle Stampe, Galleria degli Uffizi, Florence. The drawing is a preparatory study for the *Madonna of Francis I* in the Louvre. The main testing ground for Raphael was the handling of sacred groups and, in particular, versions of the *Madonna and Child* theme. The latter far surpassed the routine and somewhat lifeless grace of the Umbrian Madonnas, using movement and body language to reflect mental processes, in accord with Leonardo's teachings.

■ Raphael, *Portrait of Angelo Doni*, 1506, Galleria Palatina, Florence.

■ Raphael, *Portrait of Maddalena Doni*, 1506, Galleria Palatina, Florence. Here, the modelling is confident and imposing, added to which is the emphasis on the facial expressions of the respective subjects. Though founded on the precepts of Leonardo, this has the effect of placing them in their historical context.

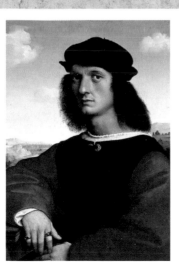

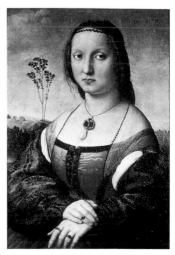

1500–1508

The Mona Lisa

The painting (c.1503–15) in the Louvre is a "cumulative" work in the Vincian sense: extremely subtle in descriptive detail, it evokes the essence of nature, diffused through space and time.

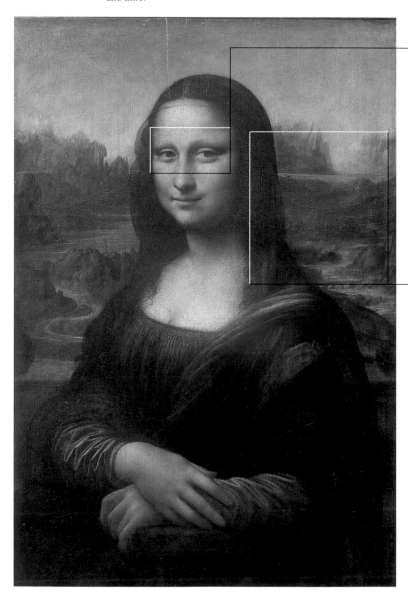

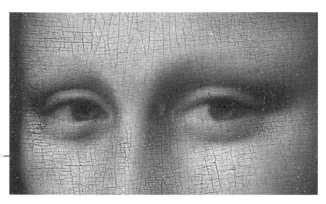

■ The proverbial smile, echoes of which are to be found in other works by the mature Leonardo, bears a suggestion both of attention and detachment, creating an unreal, abstract atmosphere.

■ Above right: Salaino, *Mona Vanna*, The State Hermitage Museum, St Petersburg. This is based on studies by Leonardo.

■ Below: Casimir Malevic, *Composition with Mona Lisa. Partial Eclipse of the Sun*, 1914, Wilhelm Lehmbruck Museum, Duisburg.

■ In the right-hand part of the landscape the bridge at Buriano (Arezzo) has been identified. Any topographical reference, however, is secondary, as the landscape has a universal significance.

■ Marcel Duchamp, *L.H.O.O.Q. Ready Made*, 1919. The *Mona Lisa* has divided the public, some loving the work, others hating it.

LIFE AND WORKS

Studies on flight and the cosmos

Leonardo's studies of the flight of birds and the manner in which the principles of flight might be adapted, naturally and artificially, for human purposes are rich in scientific observation and imaginative power. The fascination of these far-ranging investigations resides in the analogy that Leonardo sought to establish between humans and natural creatures: birds, insects, and bats. He spent many unfruitful years, during his first stay in Milan (1486–90) and his second period in Florence (1505), experimenting with a flying machine. The attempt to support and move the human body in the air failed because, in the absence of an internal combustion engine, Leonardo could not create mechanisms of propulsion capable of providing the necessary upward lift. Nevertheless, based on his understanding of air currents, pressure, and resistance, he came up with designs for machines that anticipated the modern glider, parachute, and helicopter. Related to these studies were notes concerning the cosmos, later developed by Galileo.

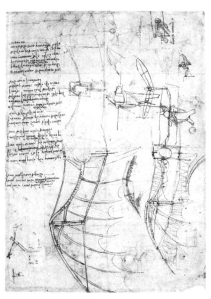

■ Leonardo, *Study of a Large Wing with Manoeuvrable Tips*, Codice Atlantico, Biblioteca Ambrosiana, Milan. Leonardo was convinced that man could achieve his objective of flight only by imitating the natural movements of birds and other winged animals.

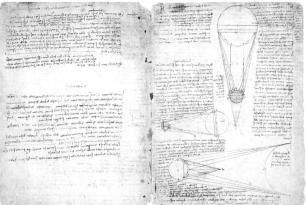

■ Leonardo, *Drawings and Notes on the Illumination of the Sun, the Earth and the Moon*, Leicester Codex, 1506–08, Bill Gates Collection, Seattle.

■ Leonardo, *Gliding Birds Exploiting the Air Currents*, c.1505, Codex on the Flight of Birds, Biblioteca Reale, Turin. "Define the power of the wind and then describe how birds steer themselves by means of a simple balancing of wings and tail." Leonardo analysed in astonishing detail the equilibrium, resistance, and flexibility of birds, as shown here by their acrobatic efficiency, flying with and against the wind, in horizontal and angled trajectories. The kite, in Leonardo's view, was the best at flying, even in the most difficult atmospheric conditions. This research also extended to other birds of prey and bats.

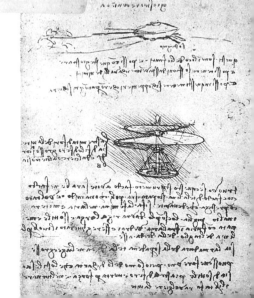

■ Leonardo, *Helical Airscrew*, c.1487, Manuscript B, Institut de France, Paris. The airscrew may be regarded as the ancestor of the modern helicopter. The plan, long pursued by Leonardo, for a flying machine that used only human muscular energy failed because he did not manage to find a system of propulsion that corresponded to the supporting strength of the wings.

1500–1508

The lost Leda

All traces of *Leda*, a pagan image to the generating power of nature, were lost in the 17th century; among the many copies and versions, the most faithful is thought to be that of Cesare da Sesto (after 1515), now in Salisbury.

MASTERPIECES

■ Leonardo, *Head of Leda and Studies of Coiffure*, Royal Library, Windsor. Leonardo returned repeatedly in his artistic and scientific works to the theme of the knot, the plait, and the vortex, as derived from Verrocchio. A pattern of spiralling motion, evident as well in the elaborate hairstyle, provides a unifying element to the figures of the woman and the swan, as well as to the botanical details of the background.

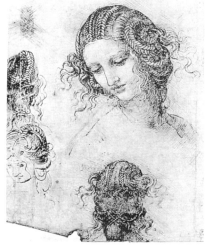

■ Leonardo, *Head of a Girl*, 1506–08, Pinacoteca Nazionale, Parma. The painting is thought by some to be associated with *Leda*, and believed by others to be a *Madonna*. At the end of the 19th century Leonardo's authorship was rejected by those who saw in it the hand of a Neoclassical painter.

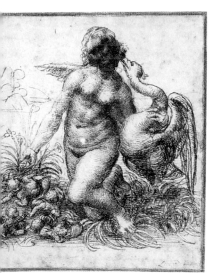

■ Leonardo, *The Kneeling Leda*, Devonshire Collections, Chatsworth. This study may have preceded the final working of the *Standing Leda*. However, the poses of the children at the woman's feet indicate associations with the classical group of the *Nile*, discovered in 1512.

■ Raphael, *Leda*, 1505–06, Royal Library, Windsor. Raphael would also borrow and develop this Leonardesque idea in the *Galatea*.

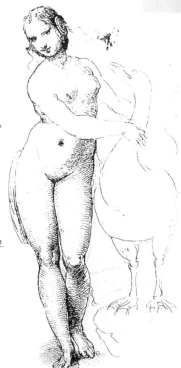

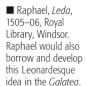

The sacred and the secular

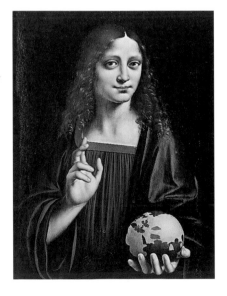

During the four years of his second stay in Florence, Leonardo went through a period of extraordinary artistic productivity, creating no less than a dozen works brought to varying stages of completion. In addition, he carried on his studies of anatomy, arithmetic, geometry, and military engineering, and took on various military and civilian duties, one of which was a project to divert the Arno River near Pisa. Between 1500 and 1508 Leonardo worked on the *Cartoon for the St Anne, Battle of Anghiari, Leda and the Swan, Madonna with the Yarn-Winder, Hercules and the Nemean Lion, Mary Magdalen, Neptune with the Sea Horses*, the *Salvator Mundi*, the *Angel of the Annunciation*, and the *Madonna and Child with the Young St John*. Only drawings survive of the two mythological subjects, *Neptune* and *Hercules*; and all that remain of the *Madonna with the Yarn-Winder*, commissioned by Florimond Robertet, secretary of the French king, and of the *Salvator Mundi*, are the versions by pupils.

■ Leonardo, *Neptune with the Sea Horses*, 1500–08, Royal Library, Windsor. This drawing was a preliminary study for the *Neptune* commissioned by Antonio Segni, a client of Botticelli. The violence of the scene is reminiscent of the work done for the *Battle of Anghiari*.

■ Marco d'Oggiono, *Salvator Mundi*, after 1494, Galleria Borghese, Rome. A copy of Leonardo's version, this painting was donated by Pope Paul V to Cardinal Scipione Borghese as the work of Leonardo. There is debate as to whether the subject was painted for the French king or to celebrate the expulsion of the Medici from Florence, which occurred on the day of San Salvatore, 1494.

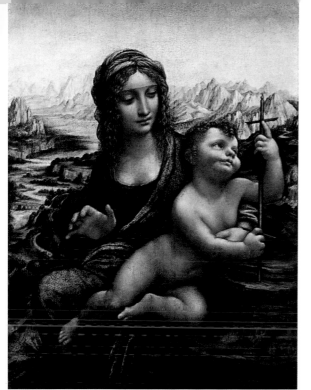

■ After Leonardo, *Madonna with the Yarn-Winder*, c.1501, Private Collection, New York. This painting derives its iconography from the apocryphal Gospels in which it is related that the Virgin spun the purple cloth destined for the temple. Seated in a landscape of mountains and streams, Mary, showing both concern and acquiescence, supports the Child, who leans against the spindle basket and holds fast the yarn-winder that has assumed the form of a cross. There is a complex symbolic and psychological interaction between the figures of the Virgin and the Child.

■ After Leonardo, *Madonna with the Yarn-Winder*, c.1501, Drumlanrig Castle, Edinburgh. Here, too, criticism fluctuates between a secular and supernatural reading. In his mature years Leonardo addressed the theme of play, here in a context of spinning and weaving, archetypal images of the Passion. Once again the gestures imply a complex chain of actions and reactions, with deep spiritual overtones.

The Milan of
Charles d'Amboise

1508–1513

The years of French domination

The cultural and political ambition of Charles d'Amboise, Count of Chaumont and governor of Milan on behalf of the French king Louis XII, heralded a revival of the golden age of patronage associated with Ludovico il Moro. As a sign of continuity with the Sforza tradition, Charles requested Pietro Soderini, gonfalonier (chief magistrate) of the Florentine Republic, to invite Leonardo to Milan, where he spent the years 1508 to 1513. Involved in the plans for Santa Maria alla Fontana, he designed for the governor a suburban villa with gardens and water displays. He painted a *Madonna and Child* for King Louis, supervised the second version of the *Virgin of the Rocks*, and created his highly original *St John*, on the precedent of his Florentine *Angel of the Annunciation*. He made studies for the Trivulzio Monument, and pursued his research into subjects that had always occupied his mind, codifying and arranging his notes on a broad range of scientific topics.

■ King Louis XII and his wife Anne of Brittany were portrayed by the French medallist Leclerc. The bronze medals, belonging to the Carrand Collection, are today housed in the Museo Nazionale, Florence.

■ Francesco de' Tatti, *The Crucifixion of the Bosto Polyptych*, 1517, detail, Sforza Castle, Milan. This provincial painter, with his robust, immediate style and folkloric approach, provides some interesting military detail in the background to this scene, notably the outlines of the Sforza Castle and troops of the French army. The French, who had conquered the duchy in 1499, ruled until 1513 when they were overthrown briefly by Massimiliano Sforza, son of il Moro.

■ Andrea Solario, *Portrait of Charles d'Amboise*, after 1507, Musée du Louvre, Paris. Summoned to the court of the French king (1507), the Lombard painter applied lessons learned from Leonardo. The thematic choice of landscape, the rhythmical handling of space, and the psychological interpretation of the subject were modelled upon Antonello and the Flemish school, still strongly rooted in local tradition.

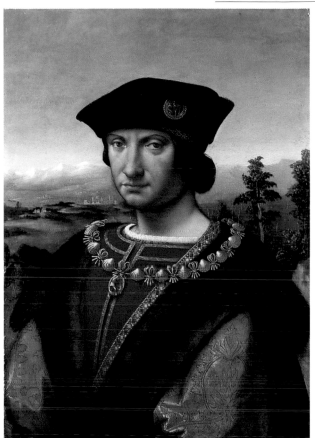

■ Giovan Gerolamo Savoldo, *Portrait of a Gentleman in Armour* (traditionally identified as Gaston de Foix), c.1510–20, Musée du Louvre, Paris, from the royal collections at Fontainebleau. The nephew of Louis XII, and the king's deputy in Lombardy, the valiant young commander, fought against the armies of the Holy League brought together by Pope Julius II. He was killed at the victorious battle of Ravenna in 1512.

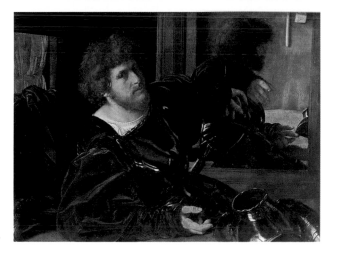

1508-1513

The Trivulzio Monument

■ Interior of the Trivulzio Mausoleum, built after 1512 by Bramante.

Fom 1508 to 1510 Leonardo made plans for the monument to be erected in the Trivulzio Mausoleum in San Nazaro, Milan, in memory of Marshal Gian Giacomo Trivulzio. The commission was never completed, and all that is left is a series of drawings embodying new ideas for representing the heroic theme of the horse and the man on horseback, previously addressed in the *Adoration of the Magi*, the Sforza Monument, and the *Battle of Anghiari*. While tackling the problems that this project entailed, Leonardo returned to the never-realized idea of a *Treatise of the Horse*. Alongside the naturalistic and scientific studies of equine anatomy, poses, and attitudes, were sketches modelled upon the subjects depicted on antique coins and jewels remembered from the Medici collections in Florence, and consonant with the heroic and celebratory nature of the subject in hand.

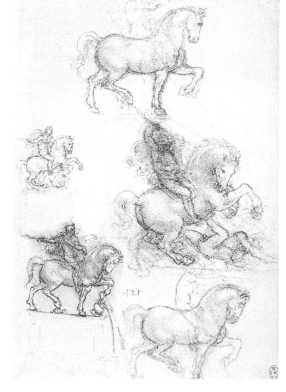

■ Leonardo, *Studies for the Equestrian Monument*, 1508–10, Royal Library, Windsor. A kind of "cinematic design", these sketches show the varied movement and rhythm of the horse. Sometimes Trivulzio was depicted as an ancient hero, nude, with his cloak swirling in the wind.

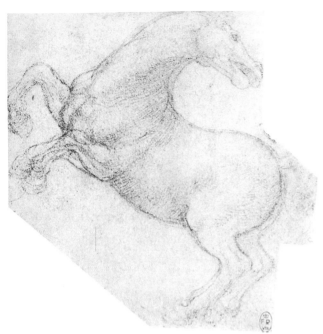

■ Leonardo, *Rearing Horse*, 1503–04, Royal Library, Windsor. The opportunity to revive a sculptural project abandoned years before led Leonardo to look afresh at themes that had already interested him in the latter years of the 15th century.

■ Leonardo, *Studies for the Equestrian Monument*, 1508–10, Royal Library, Windsor. Four prisoners were envisaged by the sides of the tomb, as in the sepulchre of Julius II.

■ Leonardo, *Study for an Equestrian Monument*, 1510–12, Royal Library, Windsor. Underneath the group there is an arch of triumph in the antique style.

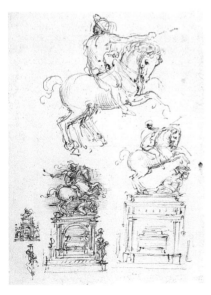

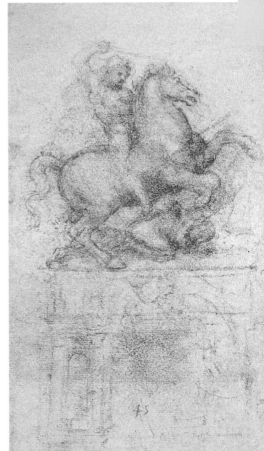

Bramantino and Gaudenzio

Despite differences in cultural backgrounds and interests, Bramantino and Gaudenzio were distinguished in the artistic environment of Milan for their originality, partly as a consequence of their association with Leonardo. Influenced in his youth by Butinone and the graphic style of the Padua and Ferrara schools, and then a pupil of Bramante, from whom he derived a flair for monumentality and drama, Bramantino was also an architect (Trivulzio Mausoleum). In his mature classical manner, as in his drawings for the Trivulzio tapestries, the painter consistently reverted to central perspectives. Moving to Rome (1508) as decorator of the Vatican Stanze, his style took on a modern tone. Bramantino's work influenced the Piedmontese Gaudenzio Ferrari, a talented painter and modeller who owed much to the Lombard artists and to Leonardo, as well as to Perugino, Raphael, Dürer, and the Flemish school. He reached full maturity with various religious paintings in the Piedmont region and subsequently founded a flourishing workshop in Milan, working at Santa Maria della Pace, Santa Maria della Passione, and other churches.

■ Bramantino, *The Month of April*, Trivulzio tapestry woven around 1509 by Vigevano tapestry makers, Sforza Castle, Milan.

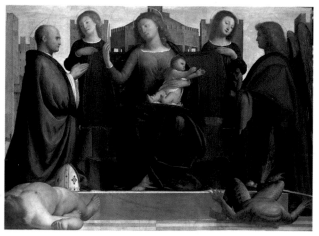

■ Bramantino, *Madonna of the Towers*, end of second decade of 16th century, Pinacoteca Ambrosiana, Milan. In the last phases of his career, Bramantino's style became increasingly monumental and enigmatic, conceived on the principles of perfect symmetry and total stillness.

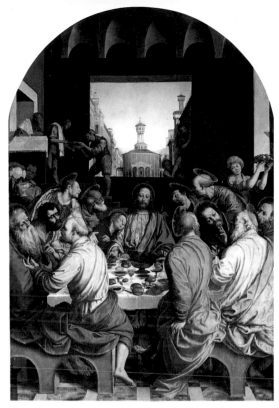

■ Gaudenzio Ferrari, *The Last Supper*, 1543, Santa Maria della Passione, Milan. In contrast to Leonardo's *Last Supper*, Gaudenzio, who was responsive to the romantic pictorial trends of the 1540s, interprets the event in the grandiose manner characteristic of the new Mannerism. The scene, animated by a narrative rhythm of great energy, opens on to an urban background dominated by a centrally planned temple.

■ Bramantino, *The Nativity*, last decade of 15th century, Pinacoteca Ambrosiana, Milan. Modelled upon Butinone, the painter uses perspective to good effect.

■ Gaudenzio Ferrari, *Martyrdom of St Catherine*, Brera, Milan. The altarpiece from Sant'Angelo testifies to the muscular power and formal innovation of the painter's late period.

The painting of the St Anne

In addition to the movement of the figures and the open surroundings, this revised version of the subject (1510–13) in the Louvre has a suggestion of water in the background, accentuating the overall sense of undulation.

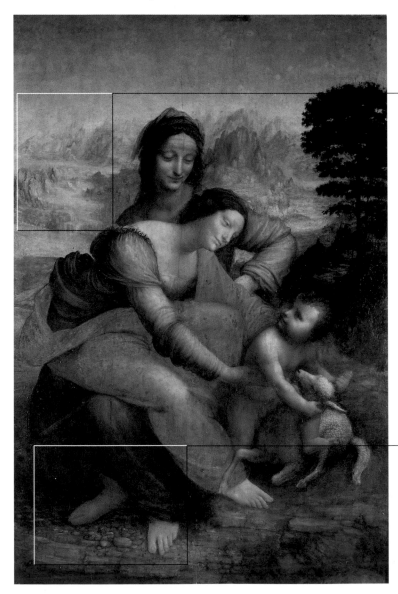

■ The figures and the natural space are harmoniously combined. A distant landscape of ice that stretches into the background suggests the dimension of time without end. It marks the culmination of a series of mountain landscapes initiated by Leonardo in the *Annunciation*. The watery translucence derives from the same technique that was used in the *Mona Lisa*.

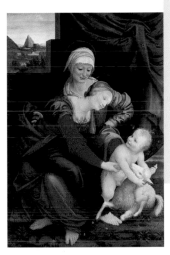

■ Cesare da Sesto, *Madonna with Child and Lamb*, 1515, Poldi Pezzoli, Milan. The figure of St Anne is here omitted, perhaps due to the decline of the saint's cult. In the landscape background, architecture of a French character fades away in the mist. The treatment shows the painter's faithfulness to Leonardo's version.

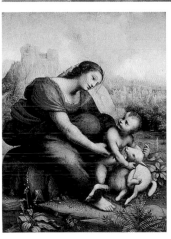

■ Bernardino Lanino, *The Virgin, the Child and St Anne*, Brera, Milan. This theme had already been treated by Raphael and del Sarto.

■ There is an uninterrupted link between the rocks in the foreground and the background; the geological and temporal stratifications of the earth's crust are the physical manifestations of the slow, continuous evolution of the world.

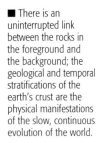

Studies of optics and perspective

Leonardo was keenly interested in optics, the science of vision, and, more particularly in perspective, the science of representation. Familiar with the Arabic and medieval scientific treatises of Alhazen, Vitellius, Roger Bacon, and John Pecham, he was also fully conversant with the theories of Piero della Francesca, Brunelleschi, and Alberti. Whilst accepting their basic premises, he felt impelled to go further by appealing, as always, to the reality of everyday experience. Even though he was concerned, like the Florentine painters of the High Renaissance, with the mathematical and geometrical basics of perspective, he criticized the abstract nature of their theories, and the concentration wholly on monocular perspective, with an observer at a fixed point. Leonardo's approach was more thorough and complex. In addition to linear or mathematical perspective he introduced two other types relative to assessment of the third dimension: chromatic, or color, perspective and vanishing perspective. The practical application of his hypotheses is evident in many of Leonardo's paintings.

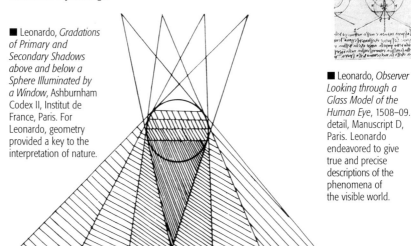

■ Leonardo, *Gradations of Primary and Secondary Shadows above and below a Sphere Illuminated by a Window*, Ashburnham Codex II, Institut de France, Paris. For Leonardo, geometry provided a key to the interpretation of nature.

■ Leonardo, *Observer Looking through a Glass Model of the Human Eye*, 1508–09. detail, Manuscript D, Paris. Leonardo endeavored to give true and precise descriptions of the phenomena of the visible world.

■ Leonardo, *Caustics of Reflection*, 1510–15, Arundel Codex, British Museum, London.

■ Restoration of the perspective of the *Last Supper* reveals the naturalism of the scene, particularly the treatment of figures in space.

■ *Luminous Rays through an Angular Fissure*, 1490–91, detail, Manuscript C, Institut de France, Paris.

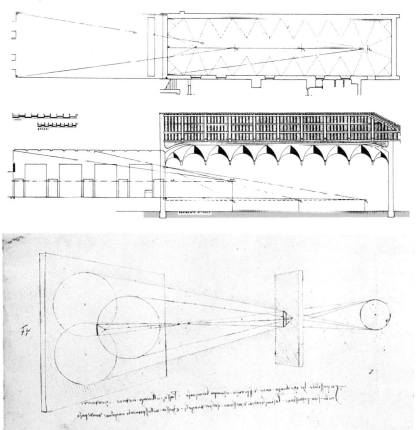

Leonardo's Milanese contemporaries

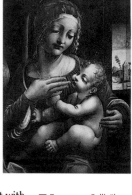

Leonardo, the initiator of modern Mannerism in Lombardy, never managed a workshop like that of Verrocchio, Raphael, or Bernini. But as far back as 1490 his style was already having an impact on a number of local artists: only Foppa and Civerchio avoided close comparison, and Bergognone, in his late phase, had no clients in the city. The first painter who came into contact with Leonardo was Ambrogio da Predis, who collaborated on the *Virgin of the Rocks*; others recorded artists were Marco d'Oggiono, Boltraffio, Francesco Galli (known as the Neapolitan), and Salaino, Leonardo's servant. Many of his contemporaries were attracted to more easily assimilable aspects of Leonardo's language: the recourse to *sfumato* and the proverbial smiles. But all too often they failed to capture the vitality and inner essence of Leonardo's creations; and above all, the fusion of art and science, which was the cornerstone of the master's achievement, escaped them entirely. Except for Cesare da Sesto and Boltraffio, the bounds within which Leonardo's pupils made their mark remained narrowly provincial.

■ Francesco Galli (Il Napoletano), *Madonna del latte*, c.1490, Brera, Milan. The modulated tones of chiaroscuro, together with the flowing sense of light, are indicative of the style of Pedro Fernandez.

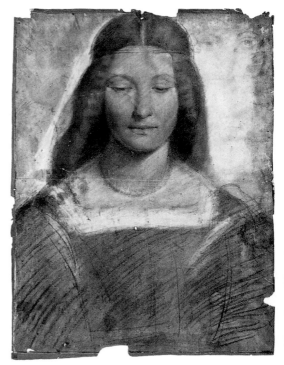

■ Antonio Boltraffio, *St Barbara*, 1502, Bodemuseum, Berlin. A loyal, though not passive, pupil of Leonardo, Boltraffio was an excellent portraitist. His figures are ample and robust, showing acute psychological insight.

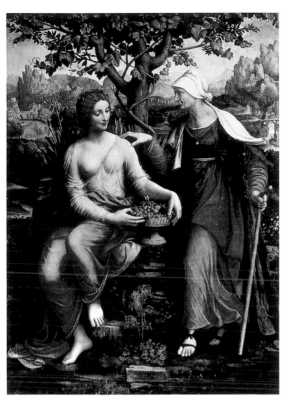

■ Traditionally attributed to Francesco Melzi, the naturalistic elements of this painting of an Ovidian subject (*Vertumnus and Pomona*, Staatliche Museen, Berlin) probably shows the collaboration of Bernazzano.

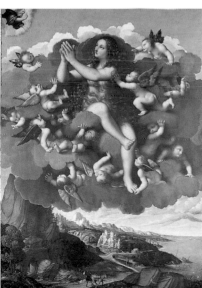

■ Marco d'Oggiono, *The Magdalen Borne to Heaven by an Angel*, Brera, Milan.

■ Giampietrino, *The Magdalen*, Brera, Milan.

■ Cesare da Sesto, *Polyptych of San Rocco*, panel, section with the Baptist, Sforza Castle, Milan. On Cesare's death (1523), the polyptych was finished by pupils.

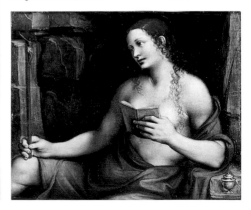

1508–1513

Followers of Leonardo in Lombardy

The influence of Leonardo in Lombardy was very pronounced during the first decades of the 16th century. This diversified and inventive circle of followers differed in cultural background and quality of product. Some, although responsive to Leonardo's stylistic innovations, remained strictly localized, whereas others seized the opportunity to expand their provincial horizons. Among the former were Bernardino de Conti and Bernardino Luini, among the latter, Cesare da Sesto, Andrea Solario, Giovanni Agostino da Lodi and, in a sense, the so-called Master of the Sforza Altarpiece. De Conti, a court portraitist, in his attempt to confront the new style, failed to throw off the rigid, archaic forms of the previous century. Luini, a prolific artist and naturally drawn to simplicity of expression, was often too ingenuous in his treatment of psychological themes. Cesare da Sesto, apart from his desire to emulate Leonardo, was familiar with the Florentines of the first decade and later with the Roman painting of Peruzzi, Raphael, and Sodoma. Influenced by Bramantino, Giovanni Agostino da Lodi possibly followed Leonardo to Venice, where he remained to make a considerable impact on various artists, including Giorgione.

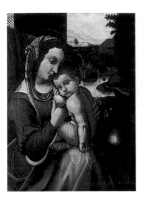

■ Bernardino de Conti, *La Madonna del Latte*, 1501, Accademia Carrara, Bergamo. Possibly a pupil of da Predis, Bernardino was a competent portrait painter.

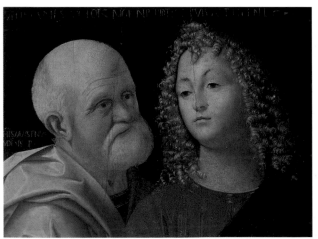

■ Giovanni Agostino da Lodi, *Saints Peter and John the Baptist*, Brera, Milan. Once known as the pseudo-Boccaccio, Giovanni Agostino, active during the first half of the 16th century, was an ambassador for Lombard art and for the work of Leonardo in Venice.

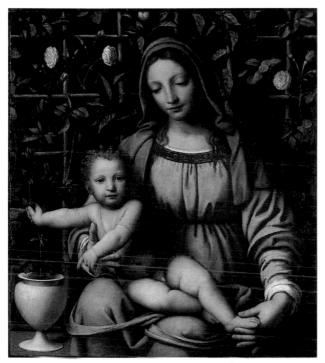

■ Bernardino Luini, *Madonna of the Rose Garden*, 1520–25, Brera, Milan (originally from the Certosa of Pavia). Although little is known even today about the upbringing and training of this painter, it is certain that as a mature artist, Luini fell completely under Leonardo's spell. A Milanese counterpart to Benozzo Gozzoli, active in Milan, Lugano, Saronno, and Chiaravalle, Luini was a prolific painter in the local tradition. On his death in 1532, his workshop was inherited by his sons Aurelio and Giovanni Pietro.

■ Master of the Sforza Altarpiece, *Madonna and Child*, first decade of 16th century, Brera, Milan. A painter whose style was solid, somewhat archaic, and sometimes overburdened, the anonymous Master of the Sforza Altarpiece has recently been identified as the Spaniard Fernando de Llanos. His work shows a surprising wealth of cultural elements.

1508–1513

St John the Baptist

Painted between the second Milanese and the Roman periods, the *St John* in the Louvre is composed in accord with an upward spiralling rhythm. The teasing expression may be an allusion to pagan eroticism.

■ An allusion to the mystery, the finger pointed towards heaven denotes the coming of Christ, announced by the Baptist. This iconographic element was frequently employed by Leonardo: it occurs in the London cartoon where St Anne indicates the heavenly will; and it returns in the drawing of the *Angel of the Annunciation*, furnished on the verso with three words taken from Pliny relating to the ability of Apelles to paint the invisible.

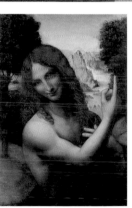

■ Salaino, *St John the Baptist*, second decade of 16th century, Pinacoteca Ambrosiana, Milan. The tree-flanked landscape is wholly Lombardian and harks back to the ice and rock background of the *St Anne*. The pupil, who followed Leonardo to France, inherited a notable number of his master's paintings.

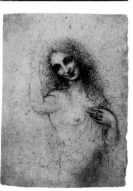

■ Leonardo, *Study for an Angel of the Annunciation*, a workshop collaboration, c.1505, private collection. The image of the angel is here transformed into that of Bacchus in a state of sexual arousal.

■ Raphael, *The School of Athens*, 1508–09, Stanza della Segnatura, Vatican, Rome. The Vincian pose reappears in the figure of Plato pointing to the space beyond the heavens.

The nature of water

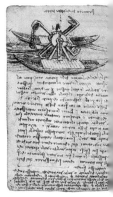

In the context of landscape painting as well as scientific and technical research, water was for Leonardo the supreme natural element, a theme to which he returned repeatedly. In the Codice Atlantico he stated his intention to write a treatise on water, and he drew up a descriptive vocabulary on the subject. The codices list various principles of hydrostatics and hydrodynamics as they relate to communicating basins, the capacity of rivers, and the wave movements of the sea. Some of these exercises were directed towards the solution of specific problems such as the projects for draining marshes – Piombino, Vigevano, Lomellina, Pontine – and to improvements in the Novara region. Other studies were related to the Lombard network of basins and canals, and the hydrographic systems of the Val di Chiana and central Tuscany. Moreover, Leonardo speculated on the alluvial origins of the Paduan Plain and the Valdarno.

■ Leonardo, *View of the Adda between Vaprio and Canonica with a Ferry and Water Intake of the Vailate Artificial Canal*, Royal Library, Windsor. Leonardo travelled to Vaprio d'Adda as a guest at the Villa Melzi.

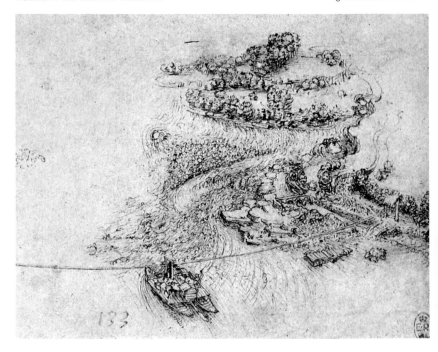

■ Leonardo, *Machine for Draining Canals*, 1513–14, Manuscript E, Institut de France, Paris.

■ Leonardo, *Canal for Navigation between the Lake of Lecco and the Lambro*, Codice Atlantico, Biblioteca Ambrosiana, Milan. The plans for widening the Adda canal were traced out around 1513. The topographical surveys conducted by Leonardo in the course of his studies of civil and military engineering were of immense importance.

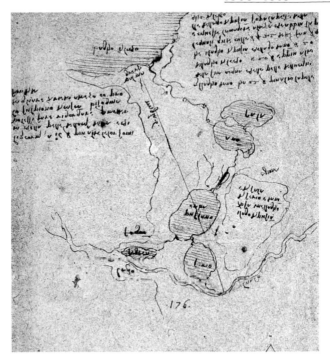

■ Leonardo, *Old Man Seated and Swirling Water*, 1513, Royal Library Windsor.

Watercourses are compared with the veins of the body and their swirling to the circulation of the blood.

■ Leonardo, *View of the Shipping of the Martesana at Concesa*, Royal Library, Windsor. Leonardo tried improve upon the location of Milan, "a city in the midst of land", by working out a plan for a new harbor-city adjacent to a river – probably identifiable as the River Ticino.

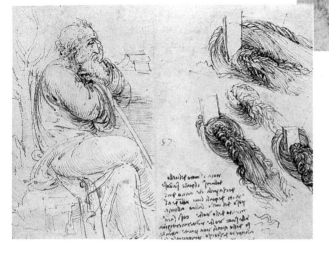

1508–1513

Bacchus

Ascribed by some to Leonardo, this painting in the Louvre was transferred to canvas in the 19th century. Others attribute it to Cesare da Sesto, to Bernazzano, to Francesco Melzi, or, more loosely, to a Lombard painter.

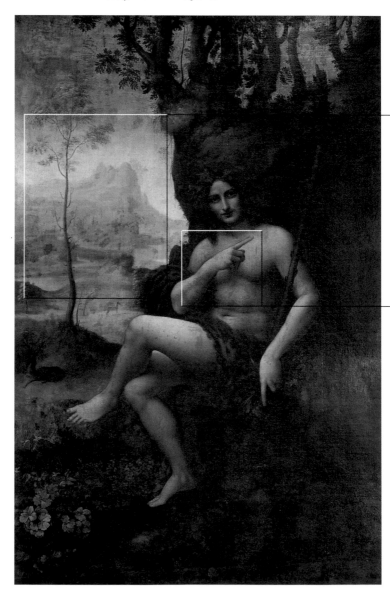

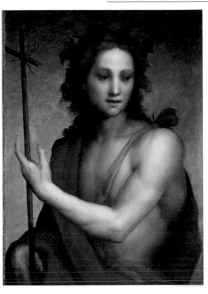

■ Taking into account the deterioration, which makes it hard to judge, the naturalistic background lacks the descriptive and symbolic density of Leonardo's landscapes.

■ As with the analogous gesture of the *St John*, the pointing index finger suggests that the subject may be identified as the Baptist.

■ Andrea del Sarto, *Bacchus*, middle of second decade of 16th century, Worcester. Del Sarto, too, combined sacred and profane iconography.

■ *The Thorn Removal,* Musci Capitolini, Rome. Leonardo's late production reverted to antique models. This pose, adopted also by Michelangelo for a *Nude* in the Sistine Chapel, returns in the *Bathing Girl* of Hayez di Brera.

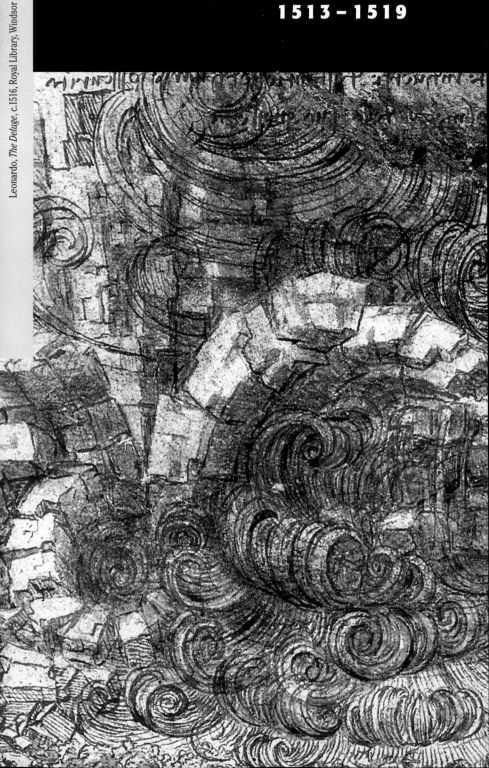

Leonardo, *The Deluge*, c.1516, Royal Library, Windsor

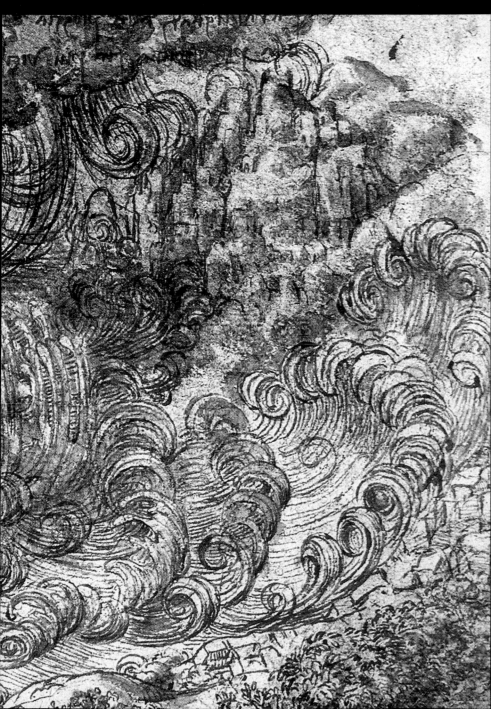

Leonardo in Rome

■ Leonardo, *Study of Dancing Figures*, c.1515, Gallerie dell'Accademia, Venice.

Possibly already residing in Rome at the time of Cesare Borgia (1502–03) and under the pontificate of Julius II (1504–05), Leonardo returned to the papal city between 1513 and 1516 when Giuliano, duke of Nemours, brother of Leo X, offered him protection. In this deeply intellectual and creative milieu, artists could meet notable figures such as Pacioli, Bramante, Giocondo da Verona, Giuliano da Sangallo, and Raphael. Leonardo's work, however, remained confined to an almost private circle: having completed the *De ludo geometrico*, he studied Archimedes, drew up plans for the drainage of the Pontine Marshes, completed a drawing of the Villa Adriana at Tivoli, and submitted plans for the gate of Civitavecchia. There is no trace of the two small pictures of the Roman period mentioned by Vasari. His studies of military architecture continued: in Latium he familiarized himself with the most recent defensive works, the fortresses of Ostia, Nettuno, and Civita Castellana.

■ Leonardo, *Scheme for the Draining of the Pontine Marshes*, 1514–15, Royal Library, Windsor. In 1515 Giuliano obtained from his brother, the pope, possession of this flooded area.

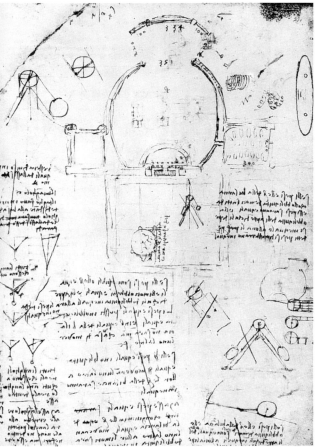

■ Leonardo, *Studies for Civitavecchia*, Codice Atlantico, c.1514, Biblioteca Ambrosiana, Milan. From 1508 Bramante was occupied with the harbor structures of Civitavecchia, in particular the defensive system and the dockyard. On Bramante's death, Leonardo was invited to the city (1513–14); this drawing may have aimed to re-evoke a harbor city of antiquity based on the configuration to be found on Roman coins. Initiated under Iulius II, the reconstruction of the fortress was continued by Giuliano da Sangallo, on the initiative of Leo X, and was subsequently completed by Michelangelo.

■ Giovanni Antonio Dosio, *View of the Courtyard of the Belvedere*, Gabinetto dei Disegni e delle Stampe, Galleria degli Uffizi, Florence. Leonardo lived in the Vatican where Pope Leo X had given him an apartment. With Giuliano de' Medici Leonardo went to Parma (1514) and Florence (1515) where he worked on restoration plans around San Lorenzo and in the Medici Palace.

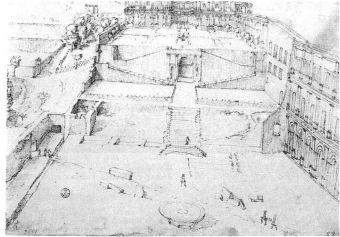

Pope Leo X and Roman culture

■ Michelangelo, *The Tomb of Julius II*, not later than 1545, San Pietro in Vincoli, Rome. The original project included the monument as part of a rededication of the church.

Under Alexander VI, Julius II, and Leo X, Rome seemed set fair to realizing the humanistic ideal of reconciling Christian and classical culture. Like his predecessor, Leo X (Giovanni de' Medici and son of the Magnificent), pursued the ideal of the *renovatio* as a symbol of the ideal continuity with the ancient city, reaffirming the cultural bond between Rome and Florence. After the pontificate of the "warrior pope", Rome appeared to be consolidating its political position, affirming the principles of universal peace and humanism, while asserting its prestige through secular wealth and luxury. Consistent with Leo X's ambitious aims were the grandiose achievements of Michelangelo, Sebastiano del Piombo and, above all, Raphael. Michelangelo, already at work on the Tomb of Julius II, moved to Florence to work on the Medici Tombs. Raphael, the successor to Bramante as chief architect of St Peter's and decorator of the Vatican Stanze, extolled the ideals of humanistic culture, and selected historical episodes as allusions to the current papacy. He received an extraordinary number of commissions. In 1515 the pope commissioned him to execute the cartoons for the tapestries for the Sistine Chapel; and his famous letter of 1519 to Leo X documented his post as keeper of the city's antiquities.

■ Michelangelo, *Lunette of the Prophet Aminadab*, 1508–12, Sistine Chapel, Rome.

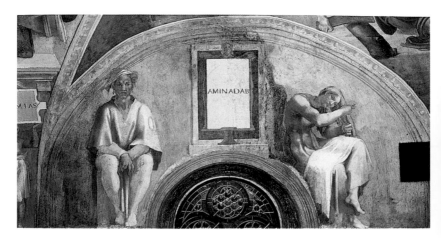

■ Cristoforo Caradosso, *Medal of the New St Peter's*, Cabinet des Médailles, Bibliothèque Nationale, Paris.

■ Raphael, *The Triumph of Galatea*, 1511, detail, La Farnesina, Rome.

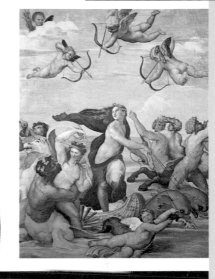

■ Raphael, *Portrait of Leo X between Two Cardinals*, 1518–19, detail, Galleria Palatina, Florence. An experienced diplomat, art lover, and patron, the pope, quite apart from his official duties, was confronted by grave political and religious problems, such as the struggle between Charles V and Francis I for the imperial succession, and the Lutheran Reformation. His pontificate was marked by scandal and corruption.

Leonardo at the French court

On the death of the duke of Nemours, Leonardo moved to the court of Francis I as "premier peintre, ingénieur, architecte du roi, meschanicien du roi", living in the palace of Cloux at Amboise on a pension of a thousand scudi, with an annuity for Melzi and Salaino as long as he lived. His famous plan for the royal palace of Romorantin with fountains and pools for aquatic jousts never came to fruition but was reflected in later châteaux. He pursued his studies in geometry, and his interest in hydraulics was manifested in the project for connecting the Atlantic and the Mediterranean by linking the Loire to the Saône. As an artist, Leonardo was still busy finishing the *Mona Lisa*, the *Leda*, the *St Anne*, and the *St John*; and he produced the drawings for the *Deluge*, which, with its obsessively catastrophic vision of nature, represented a dying universe. Francis I probably commissioned from him the anamorphosis of a lion with a dragon. He was invited to organize court entertainments, as well as the festivities for the baptism of the Dauphin and, probably, the wedding of Lorenzo Medici, duke of Urbino.

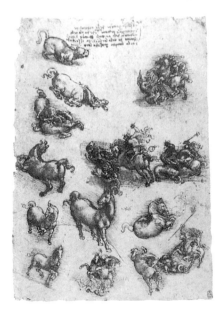

■ Above: Leonardo, *Male Costumes*, c.1513, Royal Library, Windsor. Study of a youth with a lance in parade dress.

■ Left: Leonardo, *Studies of Cats and Camels*, *St George and the Dragon*, Royal Library, Windsor. The drawings from Leonardo's old age contain a greater element of fantasy and seem disassociated from naturalistic observation.

■ Leonardo, *Sketch for the Royal Palace of Romorantin*, Royal Library, Windsor.

1513–1519

■ Jean-Dominique Ingres, *The Death of Leonardo da Vinci*, 1818, Musée du Petit Palais, Paris. The story that Leonardo died in the arms of the king is considered to belong to legend, but Francis I undoubtedly appreciated the artist's exceptional genius.

BACKGROUND

The Mannerist debt to Leonardo

■ Ambrogio Figino, *Salome*, Quadreria Arcivescovile, Milan. Formerly attributed to Cesare da Sesto, the drawing is markedly in the style of Leonardo.

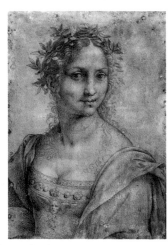

The influence of Leonardo on the creative methods of modern art was profound and enduring; yet in the field of Mannerism, the contributions of Raphael and Michelangelo seem at first glance more obvious. In Milan, where after his death the cultural picture again assumed a provincial note, Leonardo's influence, like the teaching of Gaudenzio, persisted throughout the 16th century. It featured prominently in the work of Cesare Magni, and it also influenced the style and thinking of Gerolamo, Giovanni Ambrogio Figino, and Giovanni Paolo Lomazzo. Gerolamo, associated with Cesare da Sesto and mentioned with Melzi at the cathedral workshop, brought an elegant but coldly academic approach to the Leonardesque idiom, acknowledging at times the demands of the new reforms. Other highly gifted artists to be affected were Sodoma and Correggio; the latter assuaged the severity of Mantegna with *sfumato*, and derived from Leonardo a natural generosity of approach and a talent for compositional fluency.

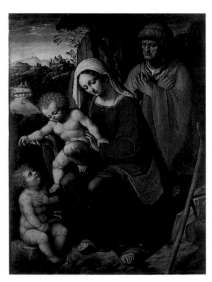

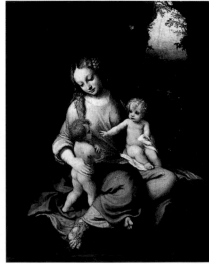

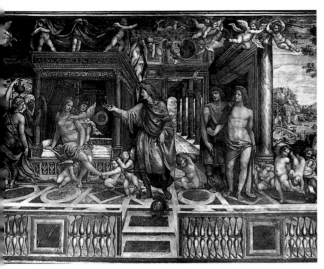

■ Sodoma, *The Marriage of Alexander and Roxane*, 1519–20, La Farnesina, Rome. After his apprenticeship in Vercelli and contact with the work of Leonardo in Milan, Sodoma moved to Rome where his style took on classical tones, alongside Raphael and Peruzzi; his debt to Leonardo, evident in his typology, was reaffirmed in his late work (*Sacred Conversation*, 1542).

■ Bernardino Lanino, *Madonna and Child with Saints*, detail, parish chuch, Borgosesia. Active in Milan and eastern Piedmont, Lanino, a pupil of Gaudenzio from 1540, brought a sentimental interpretation to the Leonardesque manner.

■ Cesare Magni, *The Holy Family with the Young St John*, Brera, Milan. A follower of Cesare da Sesto, from whom he borrowed traits from Leonardo and Raphael, Magni bears witness to the fact that Leonardo's message was deeply rooted in Lombardy even in the middle years of the 16th century.

■ Correggio, *Madonna and Child*, c.1515, Museo del Prado, Madrid. The figures, wrapped in almost tangible material, are bathed in the soft chiaroscuro of morning light.

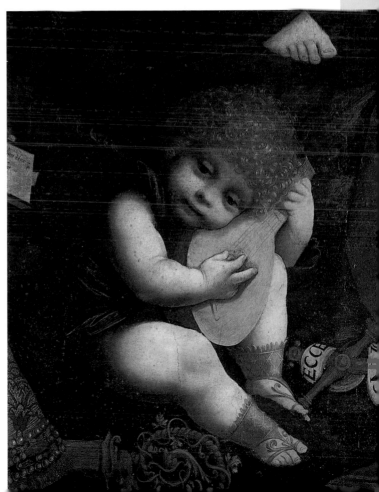

Leonardo's legacy to Europe

In both theory and practice, Leonardo's artistic influence in 16th- and 17th-century Europe, notably France, Spain, Flanders, and Germany was immense. Copies, variants, and engravings demonstrate how eagerly his range of compositions, his typological innovations, and his criteria of construction were welcomed. Along with Dürer, who, like Leonardo, studied physiognomy and proportion, other great Northern masters were seduced by his genius. Among them was the German Hans Holbein, possibly in Lombardy in 1517, whose half-length female figures bore the stamp of Leonardo; the Fleming Quentin Metsys, epitome of Northern Mannerism; and Joos van Cleve, master painter of the guild of Antwerp. The practical influence of Leonardo was still to be seen in individuals as far removed as Rubens and Rembrandt, and interest in his theoretical legacy was stimulated by the publication of his writings. The first printed edition of the *Treatise on Painting*, with illustrations by Poussin, was published in Paris in 1651.

■ Pieter Paul Rubens, *Study of Leonardo's Last Supper*, c.1600–08, Musée des Beaux Arts, Dijon.

■ Rembrandt, *Red-ochre Drawing of the Last Supper*, c.1635, Kupferstichkabinett, Staatliche Museen, Berlin.

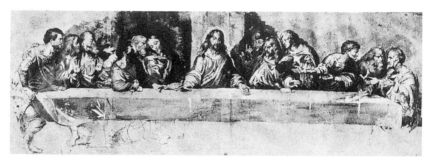

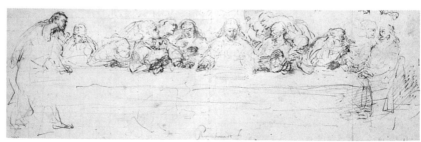

■ Quentin Metsys, *The Usurers*, Doria Palace, Rome. Both the costume scenes and the religious paintings of Metsys show the likely influence of Leonardo.

■ Joos van Cleve and collaborator, *Two Children Embracing*, c.1528, Art Institute of Chicago. Joos widened the scope of traditional Flemish painting with the lessons learned from European masters in the course of travels to Germany, Italy, France, and England.

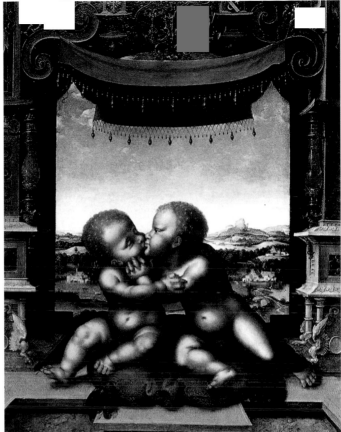

■ Hans Holbein, *Venus and Cupid*, c.1516–26, Kunsthaus, Basle.

■ Luis de Morales, *Madonna and Child*, Museo del Prado, Madrid. The Spanish painter combined the concepts of Leonardo with those of Sebastiano del Piombo and Beccafumi.

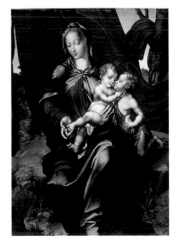

Note

*The places listed in this section refer to the current location of Leonardo's works. Where more than one work is housed in the same **place**, they are listed in chronological order.*

■ Leonardo, *Study of Geometrical Figures,* 1517–18, Codice Atlantico, Biblioteca Ambrosiana, Milan.

■ Leonardo, *Flowers,* c.1490, Institut de France, Paris.

■ Leonardo, *Studies and Diagrams,* Institut de France, Paris.

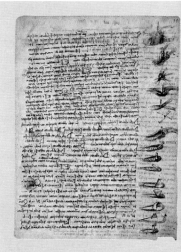

■ Leonardo, *Study of the Movement of Water,* Leicester Codex, Bill Gates Collection, Seattle.

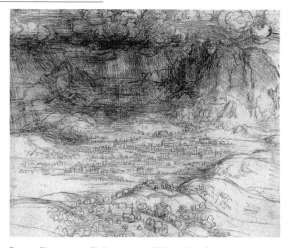

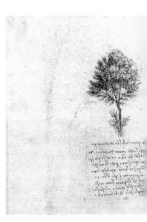

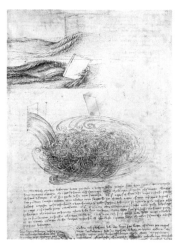

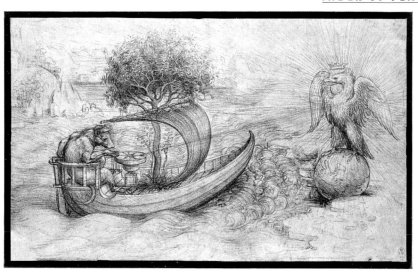

■ Leonardo, *Map of the Tuscan Coast around Pontedera, Pisa, and Leghorn*, c.1503, Royal Library, Windsor.

■ Leonardo, *Alpine Landscape*, 1499–1501, Royal Library, Windsor.

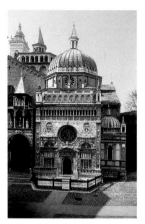

Note

All the people mentioned here are artists, intellectuals, politicians, and businessmen who had some connection with Leonardo, as well as painters, sculptors, and architects who were contemporaries or active in the same places as Leonardo.

Alberti, Leon Battista (Genoa 1406–Rome 1472), Italian architect and theoretician. In his works he followed the principle of returning to antiquity and subjected spaces and surfaces to precise geometrical regularization. An emblematic figure of the Italian Renaissance, he applied himself to the most diverse sectors of culture, writing philosophical and political texts, treatises on architecture, sculpture and painting, comedies, and literary works, pp. 9, 16, 34, 44, 108.

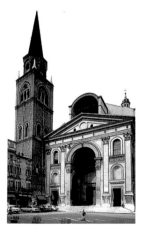

■ Leon Battista Alberti, Sant'Andrea, Mantua.

Amadeo, Giovanni Antonio (Pavia c.1477–Milan 1522), Italian sculptor and architect. He devoted himself in particular to reliefs and decorations, typical elements of Lombard architecture. His buildings provided support to the craft of stone-cutting, pp. 42, 55.

Angelico, Guido di Pietro, Fra (Vicchio, Florence c.1395–Rome 1455), Italian painter. A Dominican friar, he had a strong feeling for linear grace, picturesque detail, and varied, brilliant color. He was familiar with the spatial system invented by Brunelleschi and applied it to his paintings, bringing profound changes to the traditional iconography of the altarpiece, p. 26.

Antonello da Messina, Antonello di Antonio (Messina c.1430–79), Italian painter. In his work he managed to reconcile the study of light and taste for detail, typical of Flemish art, with the spatial sensibility of Italian culture. He was one of the greatest Italian portraitists of the 15th-century, pp. 26, 62.

Bartolomeo, Fra, Baccio della Porta (Florence 1472–Arezzo 1517), Italian painter. In his earliest works he emulated Leonardo's delicate rendering of atmosphere. After a journey to Venice in 1508, his colors became warmer and more full-bodied, pp. 74, 75.

Beatrice d'Este (Ferrara 1475–Milan 1497), married Ludovico il Moro in 1491. The court they set up in Milan was renowned for its culture and splendor, pp. 43, 50.

Bellini, Giovanni (Venice c.1432–1516), Italian painter. The great reformer of Venetian painting, he devoted himself in particular to the study of light and color tones. In the course of his long and prolific career he painted many versions of the Madonna and Child theme, portraits, and altarpieces, p. 26

Bergognone, Ambrogio, Ambrogio da Fossano

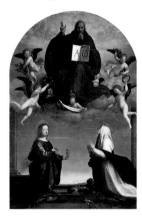

■ Sandro Botticelli,
Adoration of the Magi,
1475, Galleria degli
Uffizi, Florence.

(c.1453–1522), Italian painter.
He worked in the Certosa di
Pavia from 1488 to 1495, then
in Milan. Among his works were
two paintings of the crowned
Virgin of Lodi, the *Annunciation,*
and the *Presentation in the
Temple,* p. 46.

Boltraffio, Antonio (Milan
1467–1516), Italian painter. Trained
in the tradition of Foppa, he seems
also to have been a pupil of
Leonardo. Employed by Ludovico
il Moro, he was a fair portrait
painter with a particular interest
in reflecting the psychology of
his sitters, pp. 65, 110.

Borgia, Cesare (1475–Castello
di Viana, Pamplona 1507),
Italian politician. He rejected
an ecclesiastical career and,
with the agreement of his father,
Pope Alexander VI, sought
to create a strong state in
central Italy, pp. 68, 122.

**Botticelli, Alessandro
Filipepi, Sandro** (Florence
1445–1510), Italian painter. A
pupil from 1464 of Lippi and
then of Verrocchio, he became
involved with the Medici family
and did portraits of various
members of the family. In
addition he produced increasingly
important paintings such as
the *Adoration of the Magi,* the
Primavera, and the *Birth of
Venus,* now in the Uffizi,
pp. 9, 12, 34, 74, 75.

Bramante, Donato, di
Pascuccio di Antonio (Monte
Asdrovaldo, Pesaro 1444–Rome
1514), Italian architect and
painter. His interpretations of
classicism assumed ever bolder
and more monumental forms,
from the Milan of the Sforzas
to the Rome of Pope Julius II,
pp. 33, 44, 50, 55, 104, 122, 123.

**Bramantino, Bartolomeo
Suardi** (Milan c.1465–1530),

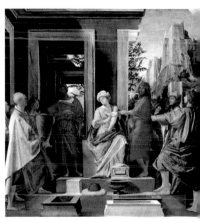

■ Bramante, *Christ
at the Column,* (detail),
1480–90, Brera, Milan.

Italian painter and architect. In
Milan, where Leonardo held sway,
Bramantino developed a sharp,
incisive style, though sometimes
disfigured by incomplete control
of architectural elements and
perspective, pp. 101, 104, 105.

Brunelleschi, Filippo
(Florence 1377–1446),

■ Bramantino,
*Adoration of the
Magi,* c.1490, National
Gallery, London.

Italian architect and sculptor,
indisputably the leading figure
of the Italian Renaissance. He
was an impassioned student
of antiquity and introduced
new systems of construction
based on strictly geometrical
rules and principles, pp. 16,
44, 54, 70, 108.

Bugatto, Zanetto
(documented 1458–74), Italian
painter. He worked for the Sforza,
having studied in Brussels in

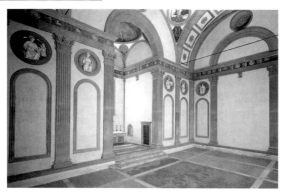

■ Fillippo Brunelleschi,
Pazzi Chapel,
Florence, interior.

Rogier van der Weyden's workshop, p. 46.

Butinone, Bernardino (Treviglio, Bergamo c.1450–c.1510), Italian painter. His contracted and miniaturized style, evident in his sharply etched figures, his rocky landscapes, and his strained expressionism, is very similar to that of the Ferrara artists, pp. 46, 47.

Cesare da Sesto (Sesto Calende, Varese 1477–Milan 1523), Italian painter. An artist strongly inspired by Leonardo, as seen in his versions of the *Madonna and Child*, he later introduced into southern Italy complex and ornate modern genres with classical scene-painting and early examples of Mannerist expressivity, pp. 94, 107, 110, 111, 112, 128.

Da Predis, Giovanni Ambrogio (Milan c.1455–Milan? post 1508), Italian painter and miniaturist. He worked at first with his brother Cristoforo, then became a painter at the Sforza court, which he depicted in miniatures. In 1483 he collaborated with Leonardo in painting the side panels of the *Virgin of the Rocks*, pp. 49, 110.

De Bardi, Donato (Pavia, active first half of 15th century), Italian painter. His activity was centred mainly on Genoa. His work, which

revealed the direct influence of Flemish art, later adopted a markedly Lombard approach, particularly echoing the luminosity of Vincenzo Foppa, p. 46.

De Conti, Bernardino (Pavia 1450–1525/28), Italian painter. A follower of Leonardo, he was also a court painter, p. 112.

Desiderio da Settignano (Settignano c.1430–Florence 1464), Italian sculptor. He mainly portrayed heads of women and children, often achieving highly realistic effects, pp. 13, 16.

Domenico Veneziano (Venice, beginning of 15th century–

Florence 1461), Italian painter. With his varied and fruitful artistic training in Rome and Florence, Domenico evolved a composite and at the same time highly personal style, becoming one of the most active painters in the promotion of humanistic art, p. 26.

Donatello, Donato di Niccolò di Bardi (Florence 1386–1466), Italian sculptor. One of the major sculptors of the 15th century, Donatello, during his extraordinarily long career, used a variety of techniques and materials to produce a wealth of expressive and imaginative masterpieces, pp. 10, 16, 17, 82.

Dürer, Albrecht (Nuremberg 1471–1528), German painter, graphic artist, and theoretician, among the greatest of all time. A student and admirer of the Italian Renaissance, he was inspired by the lucid rationality of his age

■ Vincenzo Foppa,
Bottigella Altarpiece,
c.1480–84, Pinacoteca
Malaspina, Pavia.

■ Francesco Laurana,
Eleonor of Aragon,
1468, Museo
Nationale, Palermo.

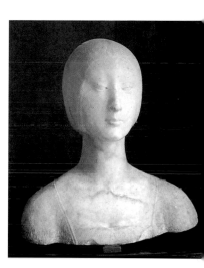

to 1458 he worked in Naples on the Triumphal Arch of Alfonso of Aragon. Two of his better known portraits were of *Eleonor of Aragon* and *Battista Sforza*, in which the features are idealized in a geometrically compact, luminous treatment redolent of Piero della Francesca, p. 63.

Lippi, Filippino (Prato 1457–Florence 1504), Italian painter. Son of the painter Filippo Lippi, on the death of his father, at little more than twelve years of age, he was already competent enough to complete the frescoes of Spoleto Cathedral. His picturesque, sometimes bizarre painting became in later years ever more taut and dramatic, pp. 26, 37, 81.

Lorenzo di Credi (Florence 1495–1537), Italian painter. He probably learned the goldsmith's trade from his father before enrolling in Verrocchio's workshop, where he was influenced by the older pupils, especially Leonardo, pp. 12, 13, 23, 26, 74.

Luini, Bernardino (1480/85–1532), Italian painter. The dating of his early activities is uncertain. He devoted himself to immense cycles of frescoes and paintings which lead to the supposition that he was head of a thriving workshop, pp. 69, 112, 113.

Marco d'Oggiono (Oggiono c.1475–c.1530), Italian painter.

■ Francesco di Giorgio, Rocca di San Leo.

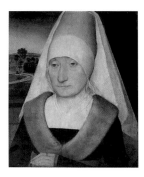

Documented as a pupil of Leonardo, he worked at Savona in the early 1500s on a now-vanished fresco cycle. He then concentrated mostly on easel painting, pp. 23, 49, 96, 110, 111.

Martini, Francesco di Giorgio (Siena 1439–50), Italian architect, painter, sculptor, and military engineer. He worked principally as an architect in Urbino, in Tuscany, and in the Marches. He wrote a *Trattato di Architectura*, fully illustrated, in which he discussed the layout of cities, and military, civil and ecclesiastical constructions, pp. 44, 55, 70.

Masaccio, Tommaso di ser Giovanni di Mone Cassai (San Giovanni Valdarno 1401–Rome 1428), Italian painter. In the course of only a few years, from 1424 to 1428, he brought about a radical transformation in painting which paved the way for the Renaissance, pp. 16, 17, 86.

■ Hans Memling, *Portrait of a Woman*, 1470–75, Musée du Louvre, Paris.

Master of the Sforza Altarpiece (Lombardy c.1480–1510), Italian painter. This is the name given to the author (now identified as Fernando de Llanos) of the altarpiece, dedicated to Ludovico il Moro and his family, now in the Brera, which shows itself to have been clearly influenced by Leonardo, pp. 42, 112, 113.

Memling, Hans (Seligenstadt 1435/40–Bruges 1494), Flemish painter. A pupil in Brussels of Rogier van der Weyden, he then settled in Bruges. He did religious paintings, genre scenes and, above all, portraits, synthesizing the styles of the great Flemish and Italian artists, pp. 20, 21, 29, 88.

Michelangelo Buonarroti (Caprese, Arezzo 1475–Rome 1564), Italian sculptor, painter, architect, and poet. He worked in Florence and then for a long period in Rome, where he left master-pieces such as the *Pietà* and the *Last Judgment*, frescoed in the Sistine Chapel of the Vatican, pp. 31, 76, 77, 78, 82, 86, 88, 123, 124, 128.

Pacioli, Luca (Borgo San Sepolcro 1445–Rome 1517), friar and mathematician, author of famous treatises, among them *De Divina Proportione*, a fundamental text for many artists choosing to study perspective, pp. 51, 54, 122.

Perugino, Pietro Vannucci (Città della Pieve, Perugia 1445/50–Fontignano, Perugia 1523), Italian painter. A pupil of Verrocchio, he soon achieved widespread renown. His refined style, deliberately rejecting the expressive approach, became accepted as an authentic style, pp. 12, 35, 74, 75, 88, 104.

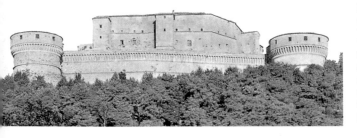

■ Perugino, *Madonna Enthroned with the Child and Two Saints*, Musée du Louvre, Paris.

■ Giorgio Vasari, *Self-Portrait*, Galleria degli Uffizi, Florence.

■ Piero di Cosimo, *Madonna with Child, Angels and Saints,* 1493, Museo dello Spedale degli Innocenti, Florence.

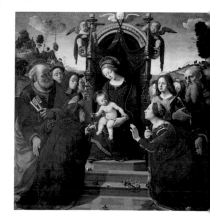

A DK PUBLISHING BOOK
Visit us on the World Wide Web at http://www.dk.com

TRANSLATOR
John Gilbert

DESIGN ASSISTANCE
Joanne Mitchell

EDITOR
Neil Lockley

MANAGING EDITOR
Anna Kruger

Series of monographs
edited by Stefano Peccatori and Stefano Zuffi

Text by Francesca Debolini

PICTURE SOURCES
Archivio Electa, Milan
Archivio Scala, Antella
Biblioteca-Pinacoteca ambrosiana, Milan
Foto Saporetti, Milan
The Royal Collection,
Her Majesty Queen Elizabeth II, London
Elemond Editori Associati wishes to thank all those museums and
photographic libraries who have kindly supplied pictures, and would be pleased
to hear from copyright holders in the event of uncredited picture sources.

Project created in conjunction with
La Biblioteca editrice s.r.l., Milan

First published in the United States in 1999 by DK Publishing Inc.
95 Madison Avenue, New York, New York 10016

ISBN 0-7894-4144-6

Library of Congress Catalog Card Number: 98-86754

First published in Great Britain in 1999
by Dorling Kindersley Limited,
9 Henrietta Street, London WC2E 8PS

A CIP catalogue record of this book is available from the British Library.

ISBN 0751307297

2 4 6 8 10 9 7 5 3 1

Printed by Elemond s.p.a. at Martellago (Venice)